JOB

APARTMENT

LANGUAGE?

FAMILY

GET
A
DOG!

ME & McDUFF

LESLIE OSCHMANN

HOW A DOG INSPIRED MY JOURNEY TO A CREATIVE LIFE

RIZZOLI
NEW YORK

New York · Paris · London · Milan

FOREWORD.

It's such a wonderful thing to have friends who surprise and inspire you. Leslie's decision to change her life and become an artist-craftsperson in the Netherlands was a real act of courage. I needn't have been concerned. She quickly went about bringing her best buddy into her world: the very photogenic, major ham McDuff. Leslie's understanding and love for her dog are amazing to see. As these pages show, they make quite a team. These two are living the dream.

Keith Johnson,
former buyer-at-large for Anthropologie
and host of Man Shops Globe

I GREW UP UNDER THE BENEVOLENT
COMMAND OF HIGHLY CREATIVE
OVERLORDS, MY PARENTS. AT THEIR
BEHEST I FETCHED PIECES OF
FABRIC, TOOLS, SCRAPS OF WOOD,
AND ANYTHING ELSE THEY
NEEDED TO COMPLETE A
PROJECT. BUSTLING ABOUT
THE CARPENTRY AND CRAFTS
WITH ME WAS OUR WIRE-HAIRED
FOX TERRIER, KATIE McDUFF
OSCHMANN. SHE WAS OUR FAMILY'S
HEART, OUR PULSE, THE PHYSICAL
EMBODIMENT OF OUR LOVE.
KATIE AND I WERE YOUNG, AND
BOTH HAPPILY IGNORANT OF CHILD
LABOR LAWS.

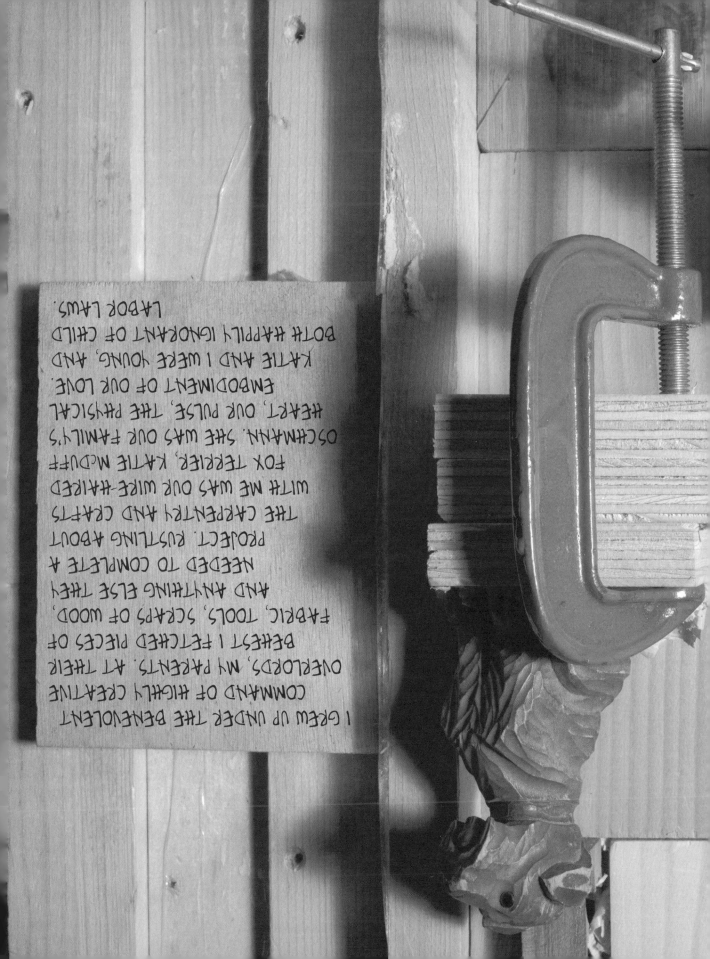

SOMETHING MISSING

MY FIRST JOB OUT OF HIGH
SCHOOL WAS DESIGNING
DISPLAYS AT A CLOTHING STORE. MY
CREATIVITY AND AMBITION TOGETHER:
A WONDERFUL PAIRING! AS THE PRESTIGE
OF MY POSITIONS GREW DURING MY 20s,
I SPENT MORE TIME MANAGING PEOPLE
AND LESS TIME DESIGNING. I MISSED
THE HANDS-ON WORK AND FOUND THAT
CORPORATE CULTURE WAS NOT FOR
ME. THUS BEGAN THE SPRING, THEN
SUMMER, THEN FALL, THEN WINTER
OF MY DISCONTENT.

AND AROUND THAT BLOCK A
FEW MORE TIMES. I WANTED A DOG,
BUT MY WORKLOAD LEFT NO ROOM FOR ONE.

A POINTED INQUIRY

Q IF I WAS NOT A SLAVE TO THE RHYTHM OF MY CORPORATE LIFE, WHAT WAS I?

A HARD QUESTION TO ANSWER. I WAS A BODY IN SPACE, DEFINITELY. DID I LIKE LONG WALKS ON THE BEACH? CANDLELIGHT DINNERS? PROBABLY. BUT I DIDN'T HAVE TIME TO FIND OUT FOR SURE.

Q AM I JUST ONE OF THOSE PEOPLE WHO COMPLAINS A LOT AND CAN'T BE HAPPY NO MATTER WHAT I'M DOING?

A NO! I TRULY LOVED MY JOB. I WORKED WITH PEOPLE I LIKED, I WAS CHALLENGED, I GOT TO BE CREATIVE. BUT THE DEMANDS OF THE JOB ECLIPSED MY PERSONAL LIFE TOO SEVERELY.

Q GIVEN THE FREEDOM TO DO ANYTHING, WHAT WOULD I DO?

a FIRST OF ALL, ASK FOR MORE WISHES. THEN ENACT WORLD PEACE, HAVE DINNER WITH DAVID BOWIE, AND SEE LOU REED IN CONCERT ONE MORE TIME. BUT THEN? HMMMM.

q DID I NEED A CLAW-FOOT TUB, GLITTERY BATH BOMB, AN EMBARRASSMENT OF POTPOURRI BASKETS, AND CURTAINS BLOWING IN A GENTLE BREEZE TO ENACT A SOUL SEARCH?

A OBVIOUSLY, YES. I'M NOT MADE OF STONE.

q WHY WAS IT SO DIFFICULT TO HAVE THE ONE THING THAT WAS MISSING — A DOG?

A IT'S LIKE YOU'RE NOT LISTENING. IT'S DIFFICULT BECAUSE I WORKED TOO MUCH. GET IT TOGETHER.

KEEP IT SIMPLE

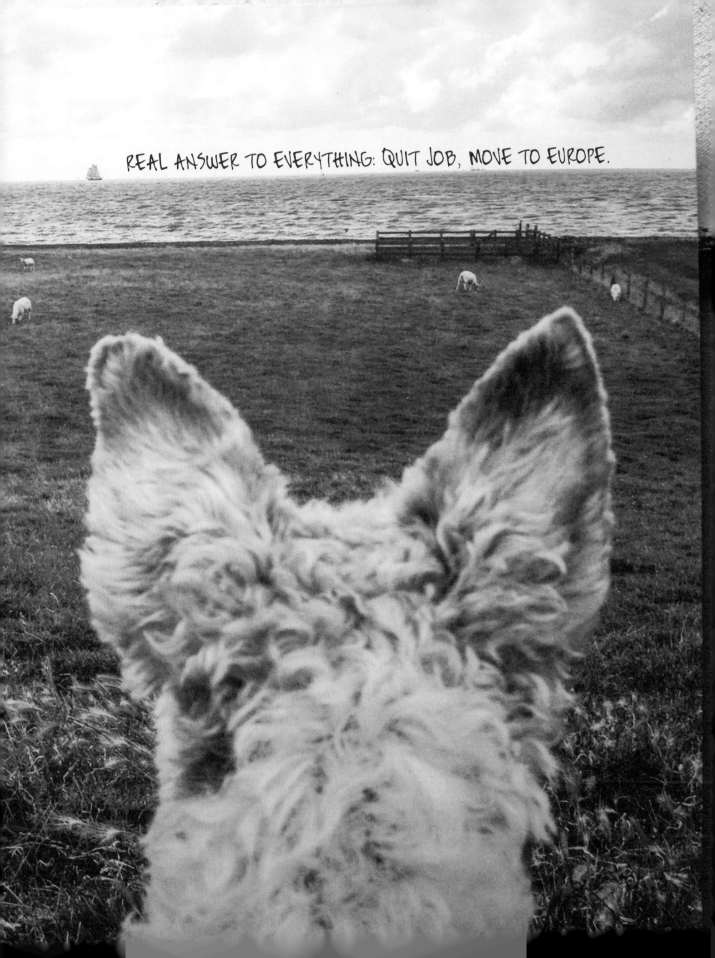
REAL ANSWER TO EVERYTHING: QUIT JOB, MOVE TO EUROPE.

WANDERLUST

I DOWNSIZED MY BELONGINGS
TO FOUR SUITCASES AND HEADED TO THE
AIRPORT. MY HEART POUNDED IN MY CHEST AS
I TRIED TO MAKE PEACE WITH THE DISTANCE I
WAS PUTTING BETWEEN MYSELF AND MY FAMILY.
THEY WEREN'T PLEASED THAT I WAS MOVING
SO FAR AWAY. BUT I HAD TO FOLLOW MY
HEART. I FLEW TO AMSTERDAM, FOUND AN
APARTMENT SITUATED AMONG THE CANALS,
AND STARTED SETTING UP MY NEW HOME.
WALKING AROUND TOWN WAS SURREAL. I
WAS IN AN UNFAMILIAR LAND WITH NO
PLAN OTHER THAN TO SLOW DOWN THE
PACE OF MY LIFE. THE CITY INVITED
ME TO SPEND LAZY HOURS SITTING ON A
BENCH, WATCHING THE CANALS RIPPLE,
OR TO MEANDER DOWN NARROW STREETS
WITH BRIGHT BLOOMS OVERFLOWING FROM
WINDOW BOXES.

COME.SIT.STAY.

AT FIRST, JUST SITTING WITH COFFEE AND A BOOK WOULD LEAVE ME IN A TOTAL PANIC. AFTER A WEEK I DOWNSHIFTED FROM PANIC TO ANXIETY. I COULDN'T SHAKE THE FEELING THAT I WAS SUPPOSED TO BE HUSTLING BREATHLESSLY THROUGH A PROJECT WITH SOMEONE ELSE'S DEADLINE. AFTER A FEW WEEKS OF PRACTICE, MY BODY FINALLY RELAXED. I EVEN GOT BORED ONCE OR TWICE. I PUSHED THROUGH IT, AND ON THE OTHER SIDE OF THESE KNOTS LOOSENING INSIDE ME WAS A STRANGE FEELING: BLISS.

DIFFERENT LANGUAGE 263

confessed to the family, "I feel helpless when
they speak a different language from

ethology, a term Jane
be but starting
she

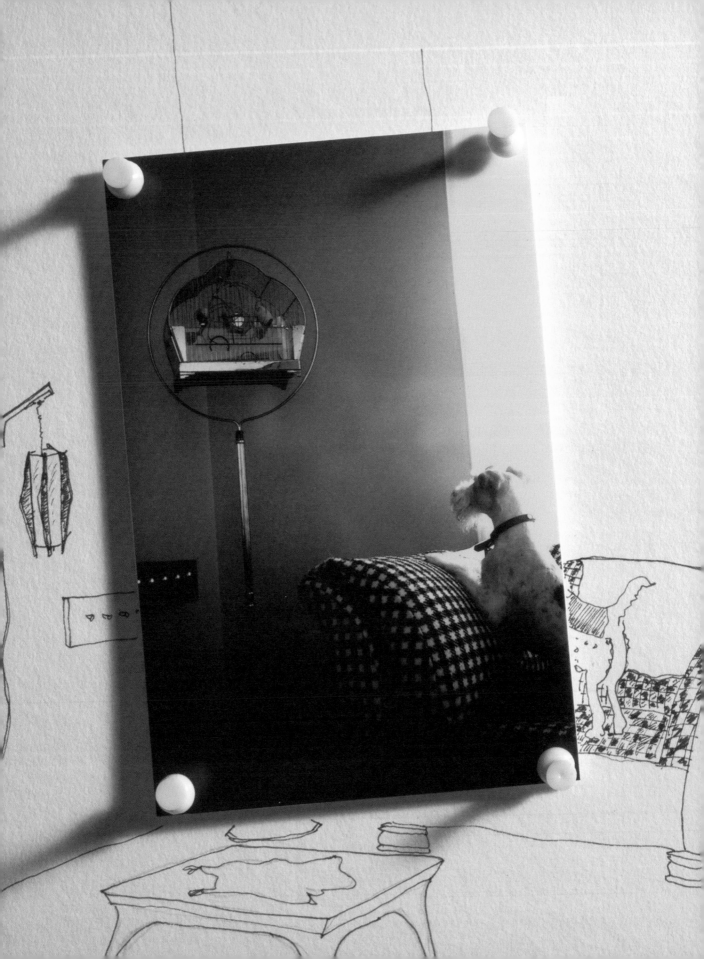

NOW IS GOOD

NOW THAT I HAD WEANED MYSELF OFF THE INTENSE
STRESS OF MY LIFE, I CONTEMPLATED MY NEXT MOVE.
MY HOME WAS COMFORTABLE, EXACTLY AS I WANTED
IT. I HAD A COUPLE OF FRIENDS, AND I KNEW WHERE
TO GET A GOOD CUP OF COFFEE. AS I WALKED PAST MY
NEIGHBORHOOD DOG PARK, MY MIND DRIFTED TO
MY CHILDHOOD PET, KATIE, AND MY LIFELONG
DESIRE TO HAVE MY OWN DOG.
I REALIZED I DIDN'T HAVE
TO WAIT EVEN A MOMENT
LONGER. EVERYTHING THAT
HAD STOOD IN MY WAY WAS GONE!
I HAD WAITED TWENTY YEARS FOR
THIS MOMENT. MY BODY HUMMED
WITH EXCITEMENT. I RAN
HOME TO MY COMPUTER
AND EXCITEDLY RESEARCHED
THE POSSIBILITIES.

AT THE DISCRETION OF A PUPPY MASTER

IN KATIE'S HONOR, I DECIDED TO
ADOPT ANOTHER WIRE-HAIRED FOX TERRIER.
MY SEARCH LED ME TO A BREEDER
LOCATED IN THE BELGIAN COUNTRYSIDE.
SHE WAS A STURDY, NO-NONSENSE WOMAN
WHO INSISTED ON INTERVIEWING ME FOR AN
HOUR BEFORE I COULD MEET THE PUPS. I WANTED
TO PASS HER TEST, THOUGH I DIDN'T KNOW EXACTLY
WHAT IT WAS. SHE BARELY SPOKE ENGLISH AND
I HARDLY SPEAK FLEMISH. WHAT WOULD IT TAKE
TO FAIL? I HAD TRAVELED
ACROSS INTERNATIONAL
BORDERS FOR THIS ANIMAL!
COULD I DO THAT AND BE A
MONSTER? ACCORDING TO HER,
ABSOLUTELY.

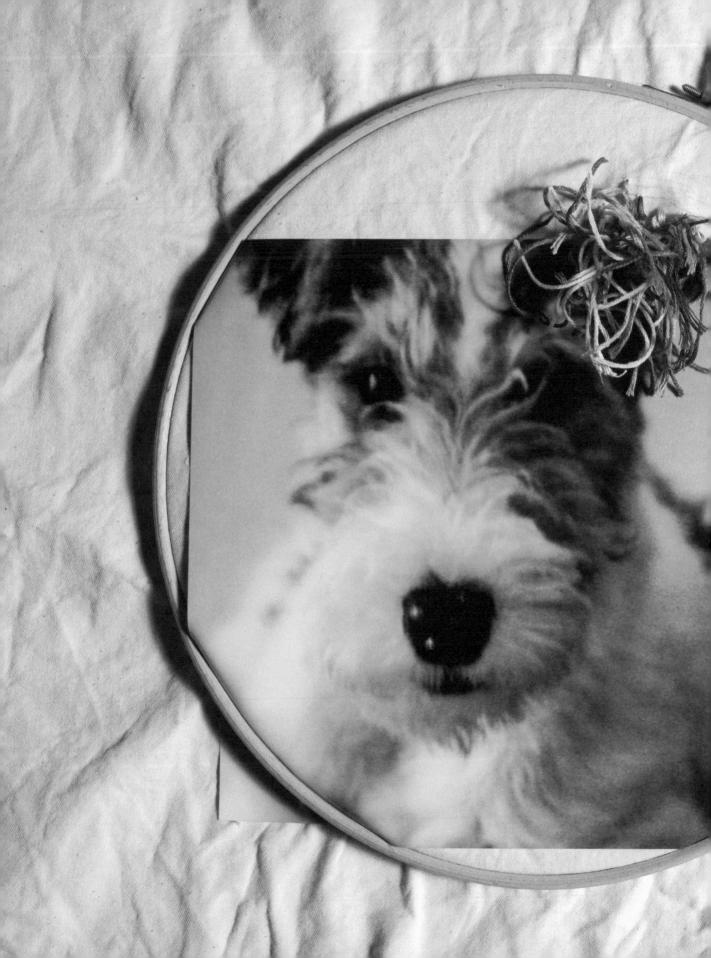

DEATH BY PUPPY

WHEN I MET THE EIGHT WIGGLING PUPPIES, MY MIND JUMPED TO AN INTERVIEW I HAD READ YEARS BEFORE. A CELEBRITY WAS ASKED HOW HE WOULD LIKE TO DIE. HIS ANSWER WAS, "BEING LICKED TO DEATH BY A GANG OF PUPPIES." I WAS IN THE BEST KIND OF DANGER: POTENTIALLY FATAL BUT NONE AT ALL! I PICKED UP A FEMALE, AND SHE MELTED IN MY ARMS. SHE MIGHT BE THE ONE, I THOUGHT. BUT THERE WAS ANOTHER PUPPY, A MALE, ATTACKING MY PANT-LEG JUST LIKE KATIE DID WHEN I WAS A CHILD. THE BREEDER POINTED TO THE PUPPY CHEWING UP MY LEG AND SAID, "HE IS A GOOD FIT FOR YOU." I KNEW IN MY HEART THAT SHE WAS RIGHT. I TOOK HIM HOME.

MY NEW DOG'S PUREBRED PAPERS STATED HIS LINEAGE AND HIS GIVEN NAME. LIKE RACEHORSES AND YACHTS, PUREBRED DOGS ARE USUALLY GIVEN SHAMELESSLY FLAMBOYANT NAMES. I EXPECTED TO FIND AN "ARCHIBALD" PAIRED WITH A "BEAUREGARD." TO MY SURPRISE AND DELIGHT, MY DOG'S GIVEN NAME WAS SIMPLY "DARYL." AS CHARMING AS IT WAS, I HAD TO GIVE HIM HIS TRUE NAME: McDUFF.

ALL IN A NAME

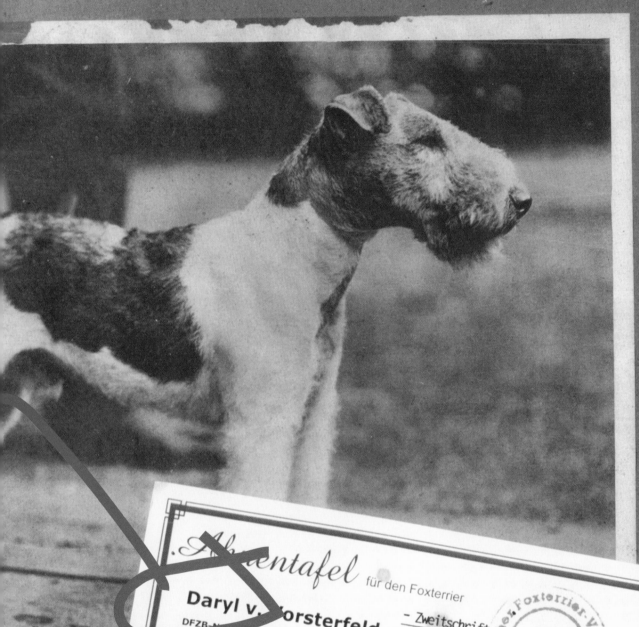

Ahnentafel für den Foxterrier

Daryl v. Forsterfeld — Zweitschrift

DFZB-Nr.: 06 4515
Wurftag: 24.09.2006 Chip-Nr.:
Haarart: Drahthaar
Geschlecht: Rüde Züchter:
 Anschrift:

	Knight Rider of the Ambitious Home
Ch. (BE/NL/LUX) Vigo of the Ambitious Home	Ch. (AM) Senor Pa

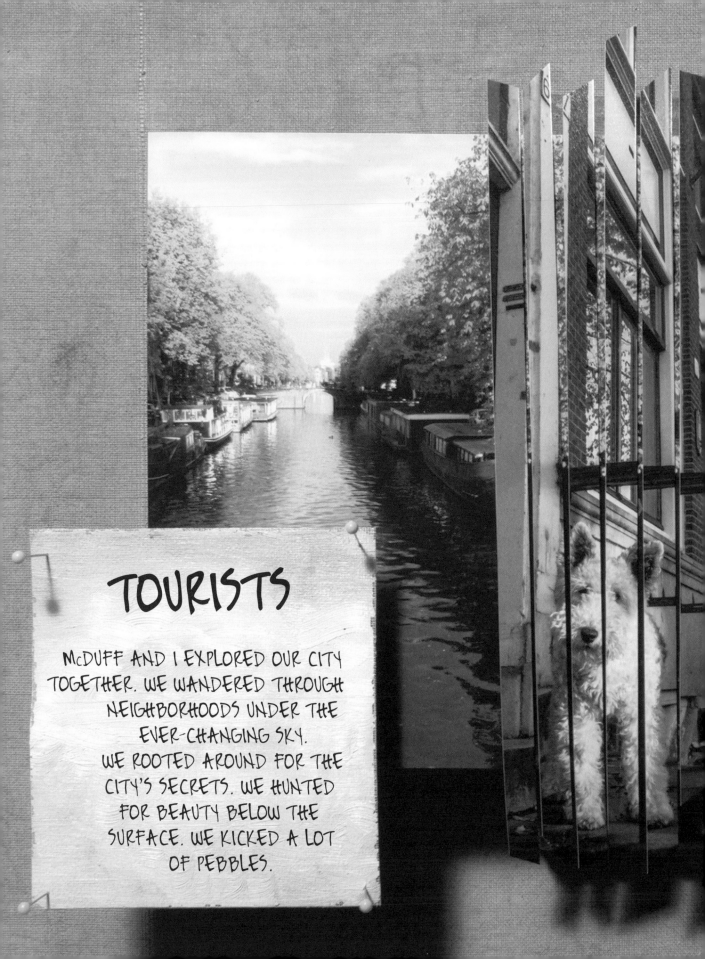

TOURISTS

MCDUFF AND I EXPLORED OUR CITY
TOGETHER. WE WANDERED THROUGH
NEIGHBORHOODS UNDER THE
EVER-CHANGING SKY.
WE ROOTED AROUND FOR THE
CITY'S SECRETS. WE HUNTED
FOR BEAUTY BELOW THE
SURFACE. WE KICKED A LOT
OF PEBBLES.

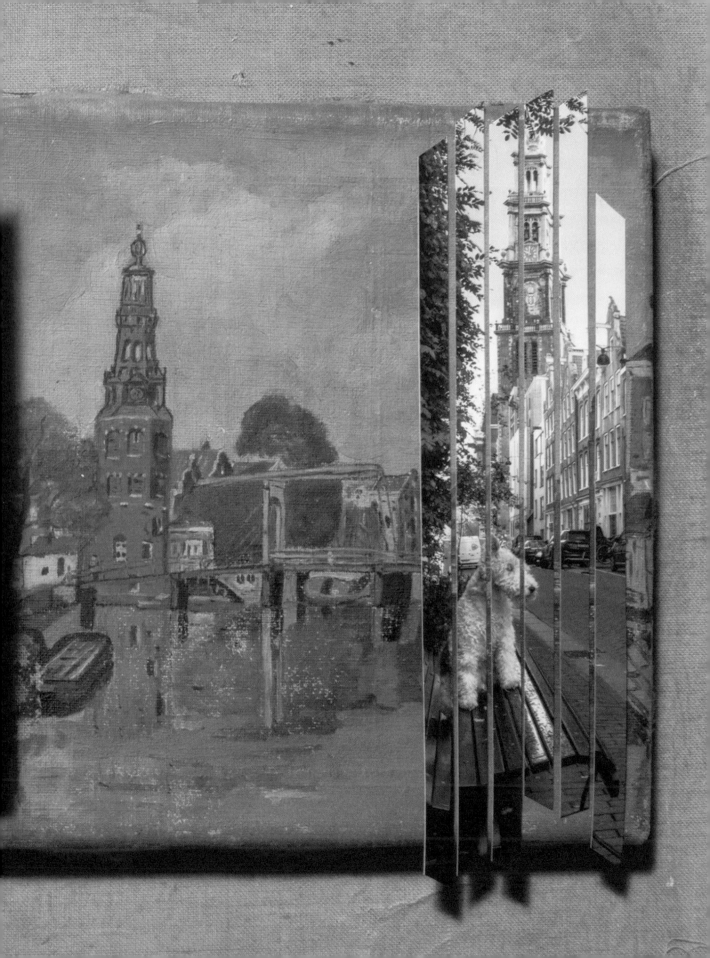

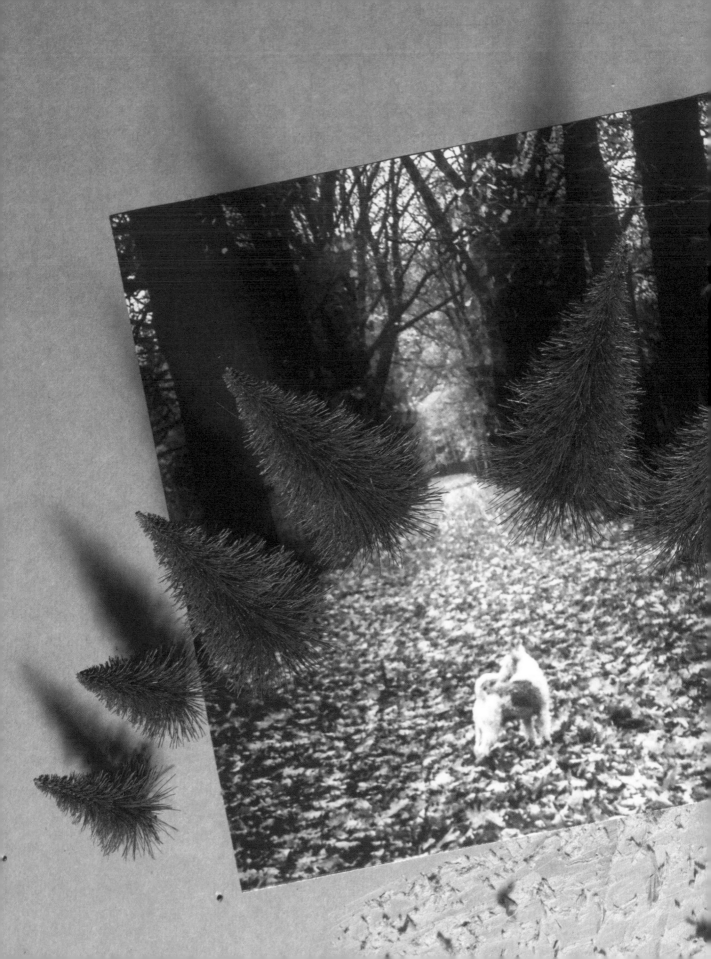

PARK LIFE

BEFORE McDUFF'S ARRIVAL, I WOULD GO TO DOG PARKS JUST TO WATCH THE DOGS PLAY. NOW, I COULDN'T WAIT TO ADD MY OWN DOG TO THIS EXUBERANT MIX, AND TO MEET THE LOCALS. IT WAS TIME TO LEARN THE RULES OF ENGAGEMENT. WHAT DO YOU SAY WHEN YOUR DOG HAS BEEN RUDE TO ANOTHER?

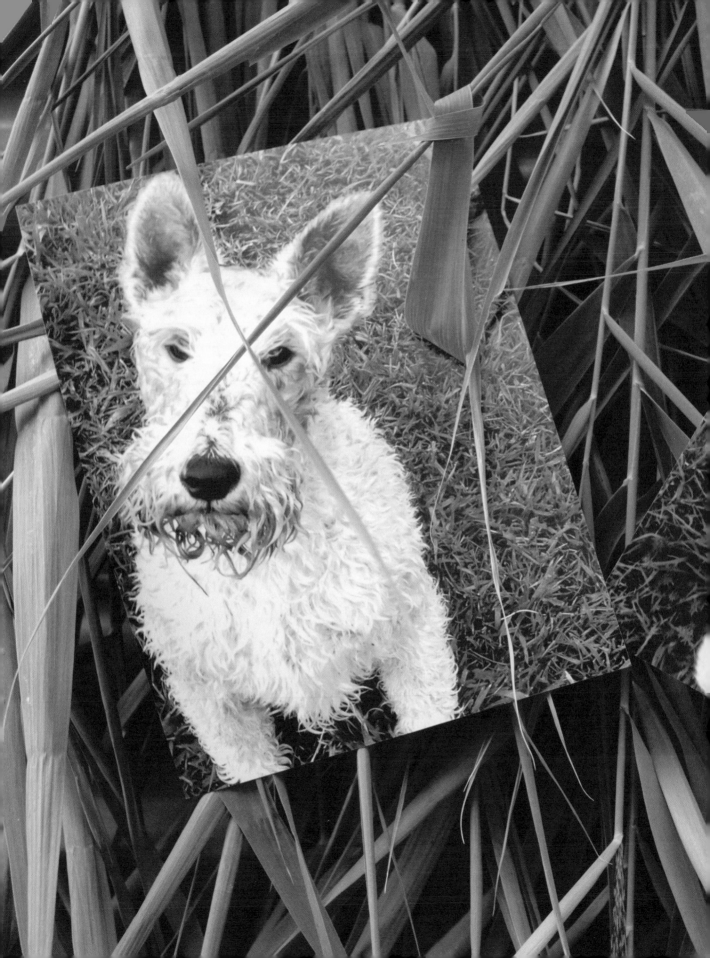

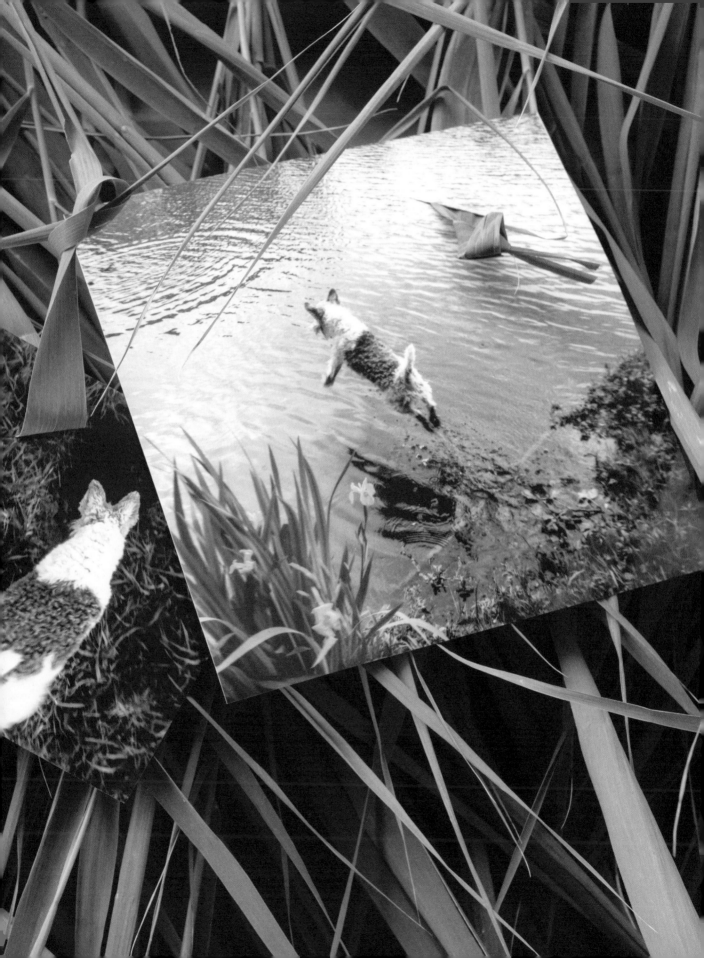

ALTER EGO

McDUFF MIGHT SEEM TO BE A TOTAL PARTY BOY, BUT LIKE ALL CREATURES GREAT AND SMALL, HE HAS A SHADOW SIDE. HIS TENACIOUS, CONFIDENT TERRIER SPIRIT CAN CREATE PROBLEMS AT TIMES. HE'S FEARLESS ABOUT GOING HEAD-TO-HEAD WITH A DOG THAT IS FIVE TIMES HIS HEIGHT AND WEIGHT.

I OFTEN WONDER, AS I CLEAN HIS WOUNDS: IS HE REMARKABLY BRAVE OR INCREDIBLY STUPID?

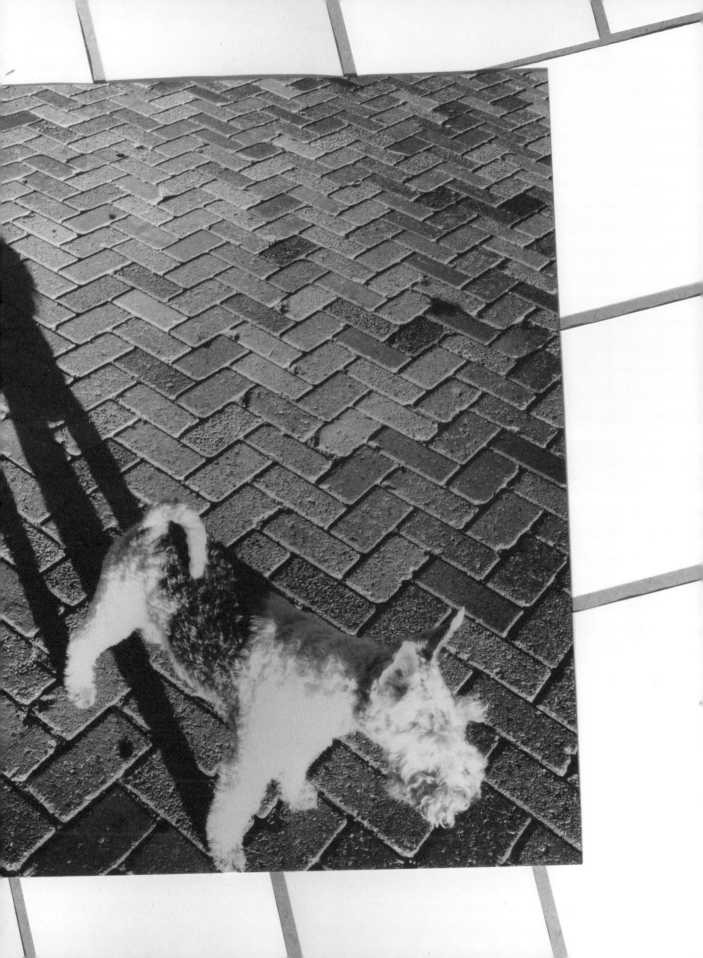

McDUFF / "NAPOLEON"

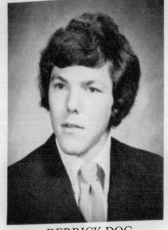

DERRICK DOG

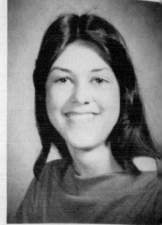

MEL MUTT

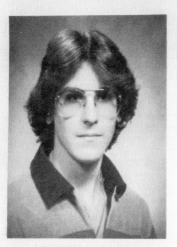

PATCH PARSONS

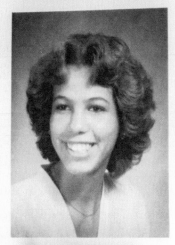

BOBBY PETERSON

MOES / "GIRLFRIEND IN CHARGE"

DOUGIE DOG

MORRIS / "THE BACK UP"

TERRI R. PIEPER

POOCH PIOTROWICZ

RUFUS

SUZIE P

BOHR / "THE REAL DOG"

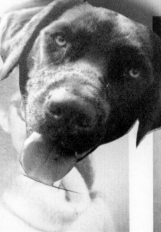

JACKIE / "THE MATRIARCH"

HOWL POWELL

WE STARTED SEEING THE SAME PEOPLE AND DOGS AT THE PARK REGULARLY. I LEARNED NOT TO MICROMANAGE McDUFF'S ANTICS (LEAVE HER ALONE! DON'T PLAY TOO ROUGH! THAT'S NOT YOUR TOY!) AND TRUST THAT WHATEVER HAPPENED, WE WOULD WORK IT OUT. THE UNEXPECTED BENEFIT OF McDUFF'S BRAWLS WAS MEETING HIS OPPONENTS' OWNERS. SOMEHOW HE ALWAYS CHOSE TO MESS WITH THE DOGS WHO HAD THE BEST CARETAKERS. I MET AT LEAST HALF OF MY CLOSEST FRIENDS AS WE PULLED OUR DOGS APART. PRECIOUS!

THE CHARIOT

McDUFF'S LOVE OF THE BIKE IS INSATIABLE. I CAN JUST
TOUCH THE HANDLEBARS AND HE COMES RUNNING.
McDUFF WAS A PRO PASSENGER FROM DAY ONE. HE
STANDS IN THE BASKET, LOOKS STRAIGHT AHEAD, AND
GRACEFULLY BALANCES THROUGH TURNS AND BUMPY
SURFACES. PURE JOY RADIATES OFF OF HIS SMALL BODY.
HIS FAVORITE ACTIVITY IS SCARING THE DAYLIGHTS OUT OF
PEDESTRIANS WALKING THEIR DOGS NEARBY. HE WAITS FOR THE
PERFECT MOMENT THEN BARKS LIKE A MANIAC. IT MAKES ME
LAUGH EVERY TIME. AT RED LIGHTS HE TURNS AROUND TO FACE
ME, THEN SITS AND WAITS PATIENTLY FOR A TREAT. WHEN
THE LIGHT TURNS GREEN, HE STANDS UP, FACES FORWARD,
AND LOOKS FOR THE NEXT UNSUSPECTING PEDESTRIAN AND
HER LOWLY WALKING DOG. SUCKERS.

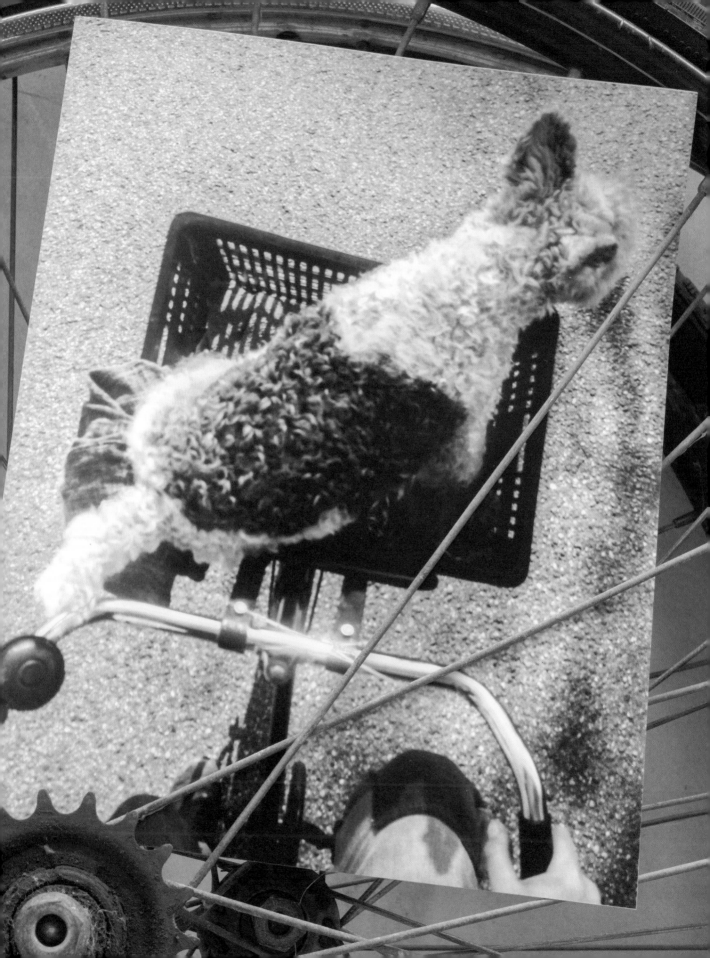

AN INSPIRED START!

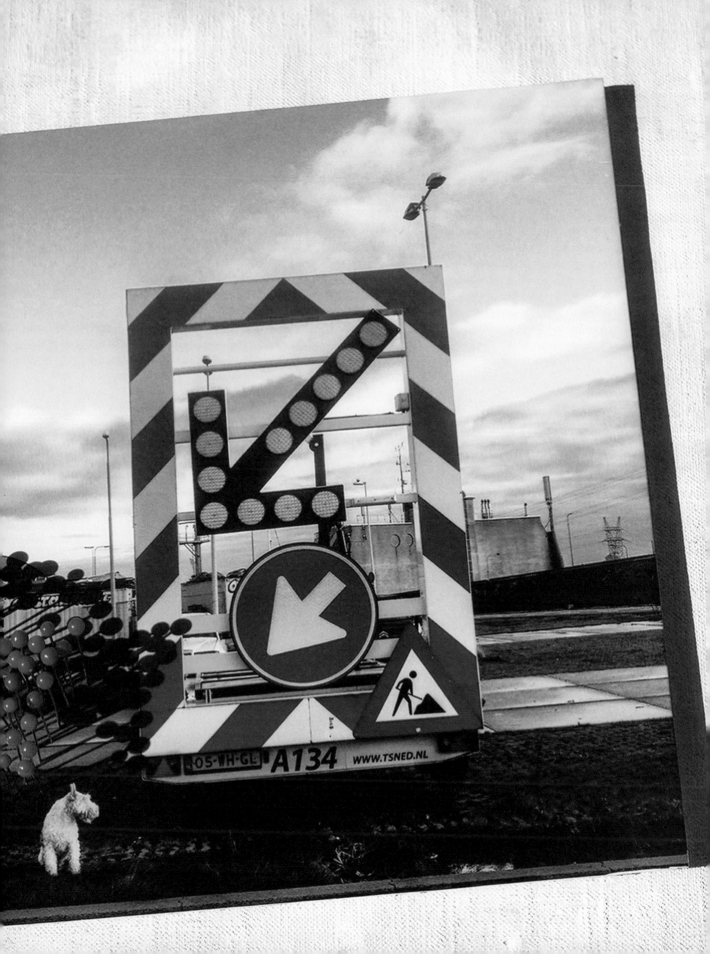

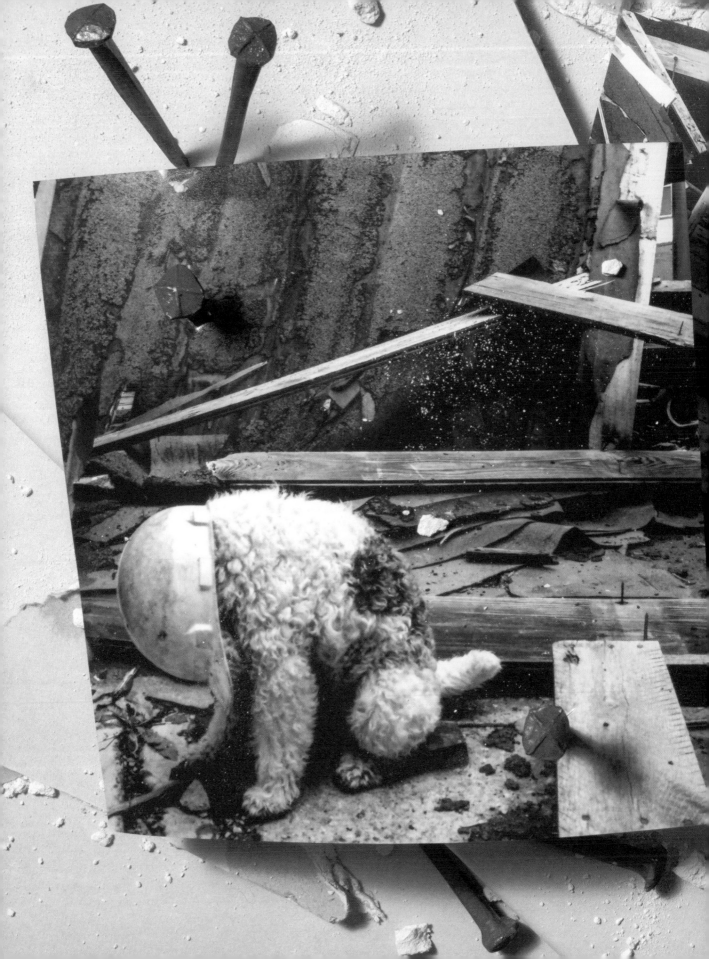

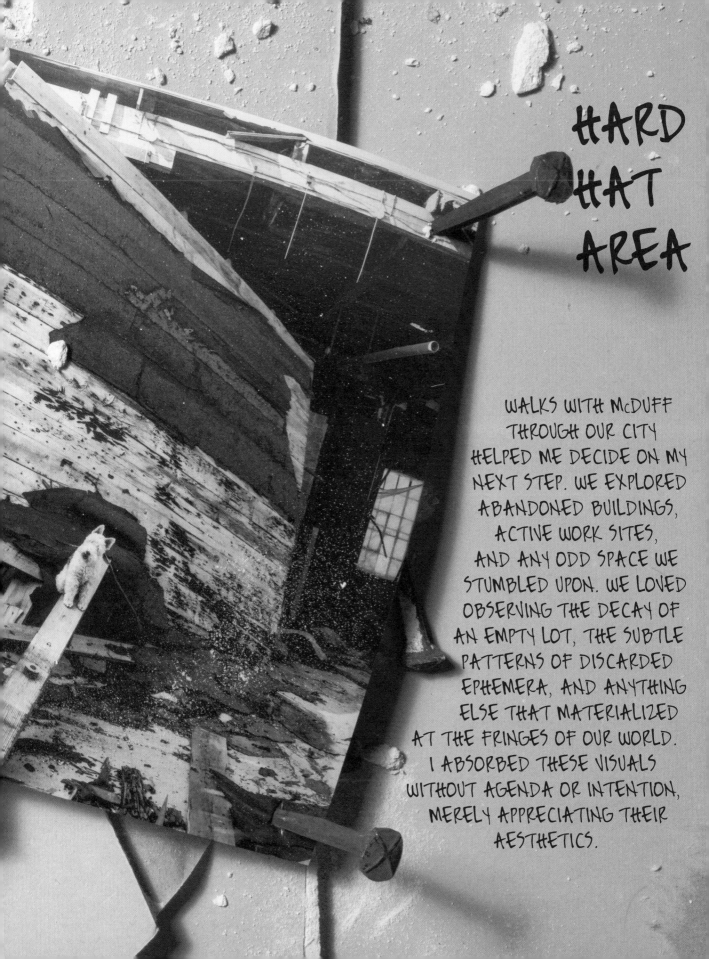

HARD HAT AREA

WALKS WITH McDUFF THROUGH OUR CITY HELPED ME DECIDE ON MY NEXT STEP. WE EXPLORED ABANDONED BUILDINGS, ACTIVE WORK SITES, AND ANY ODD SPACE WE STUMBLED UPON. WE LOVED OBSERVING THE DECAY OF AN EMPTY LOT, THE SUBTLE PATTERNS OF DISCARDED EPHEMERA, AND ANYTHING ELSE THAT MATERIALIZED AT THE FRINGES OF OUR WORLD. I ABSORBED THESE VISUALS WITHOUT AGENDA OR INTENTION, MERELY APPRECIATING THEIR AESTHETICS.

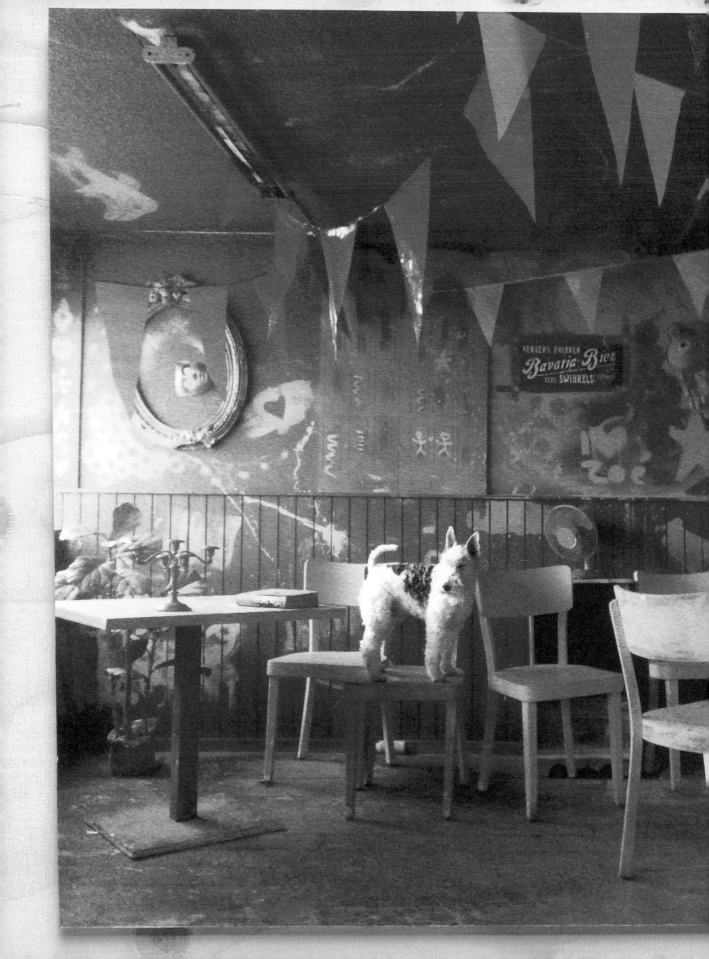

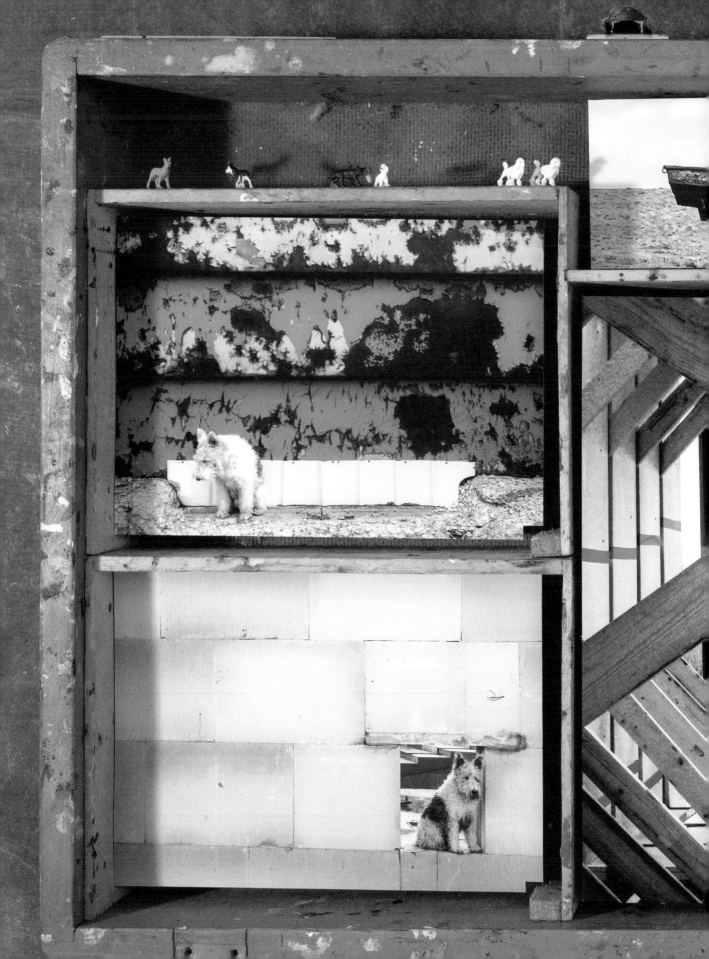

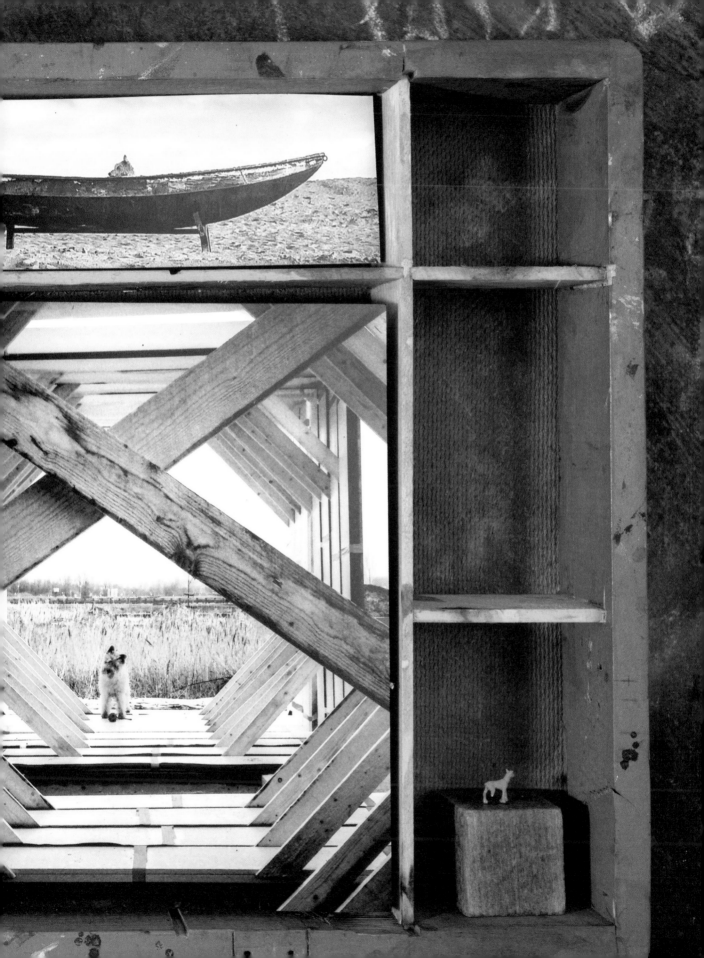

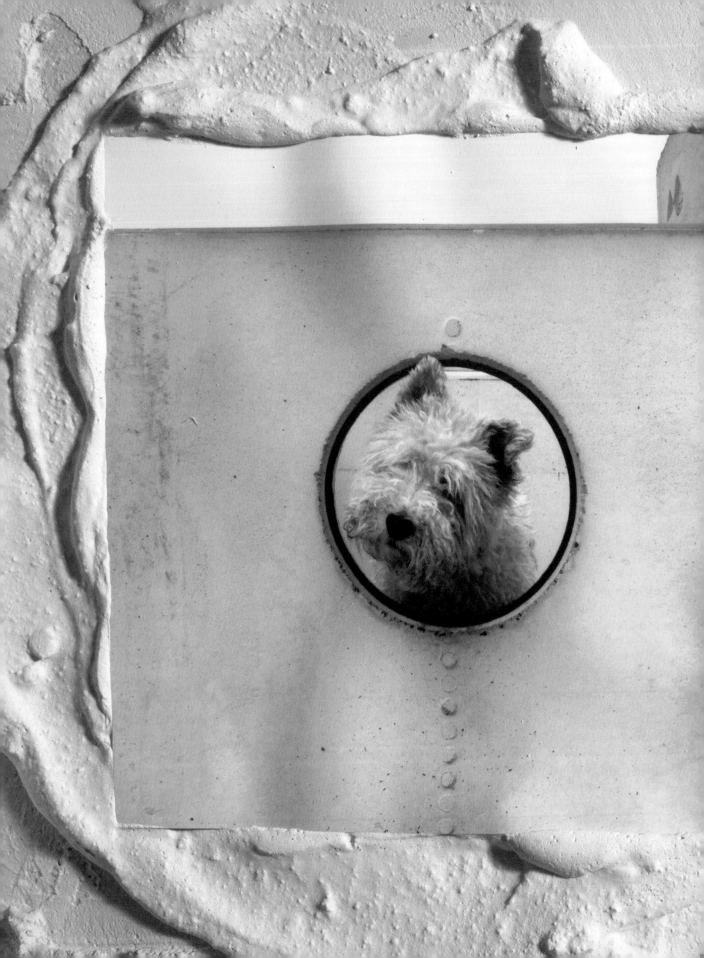

A DAWNING OF DIRECTION

I REALIZED THAT I WANTED TO BE A MAKER, AND THAT MY WORK WOULD BE AN INTERPRETATION OF MY WANDERINGS WITH McDUFF. I TOOK DISCARDED PAINTINGS AND PULLED THEIR CANVASES FROM FRAMES, THEN STRETCHED THEM AROUND CHAIR BACKS AND SEATS. I CAST FOUND OBJECTS INTO SMALL CHUNKS OF CEMENT, WHICH BECAME WALL HANGINGS. I CRAFTED HANDBAGS OUT OF REJECTED PAINTINGS AND SCAVENGED FABRIC. WORK BECAME FUN, INSPIRED, AND MEANINGFUL. MY DRIVE TO DREAM UP WAYS TO USE MATERIALS WHOSE FIRST LIFE HAD EXPIRED WAS STRONG, AND I PURSUED IT THIRSTILY.

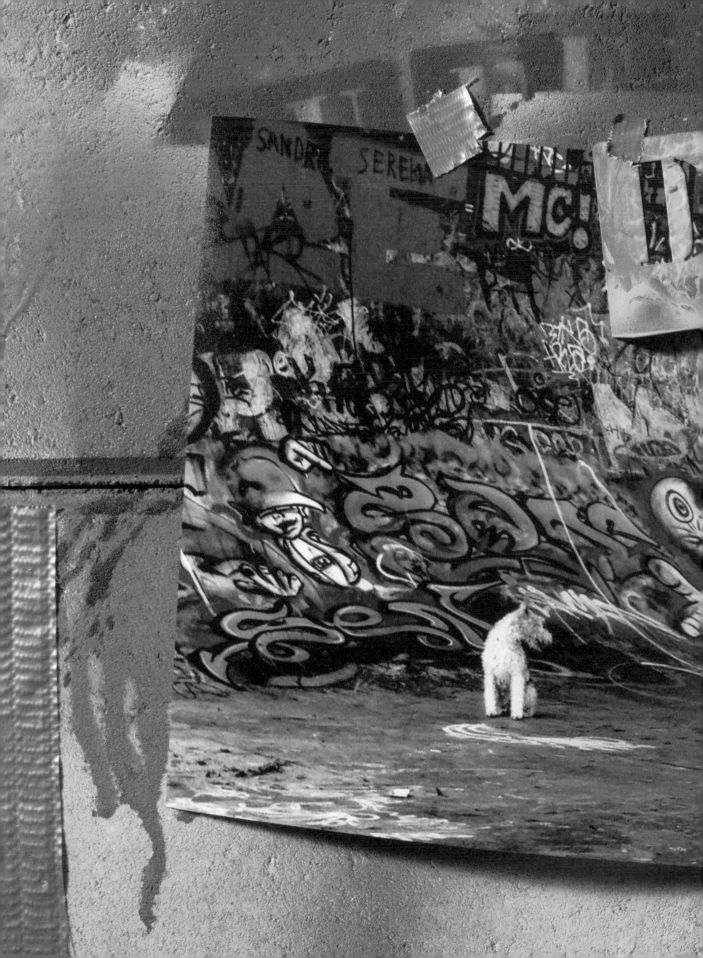

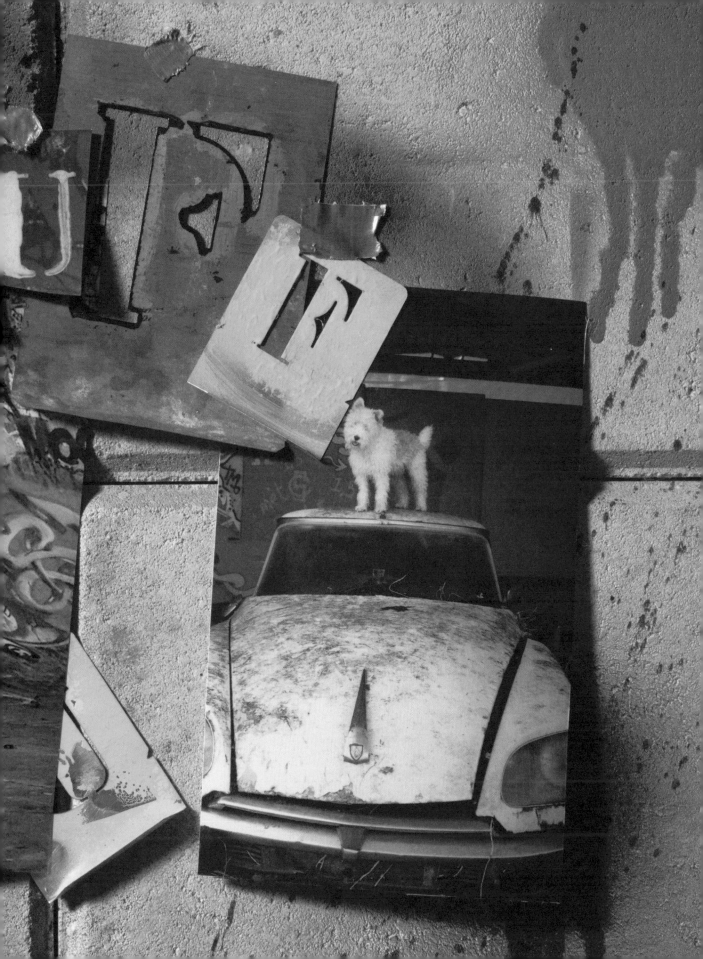

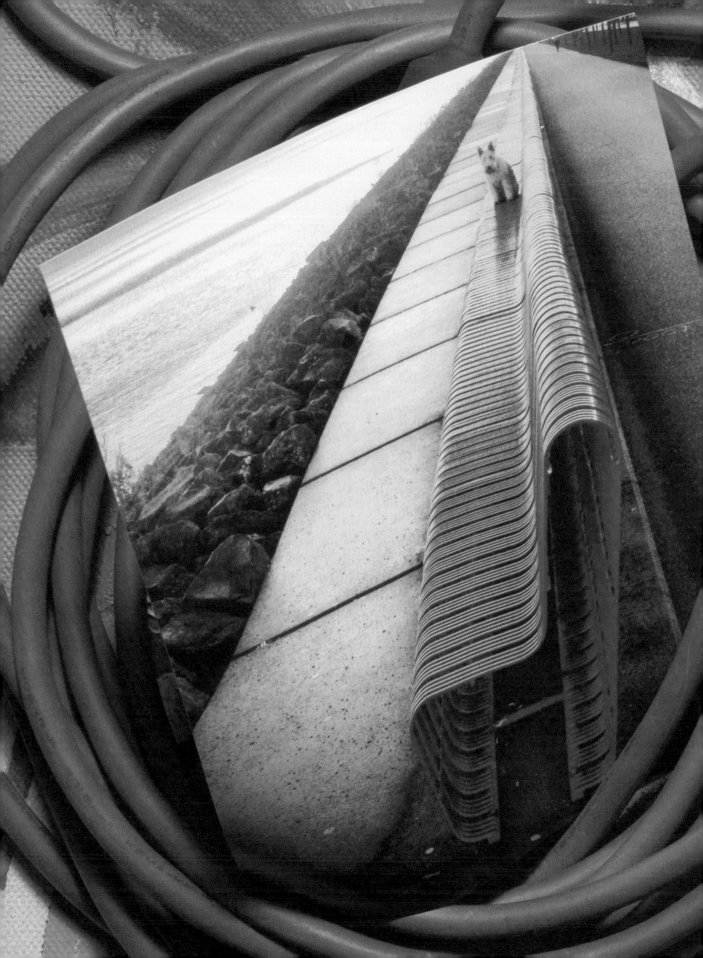

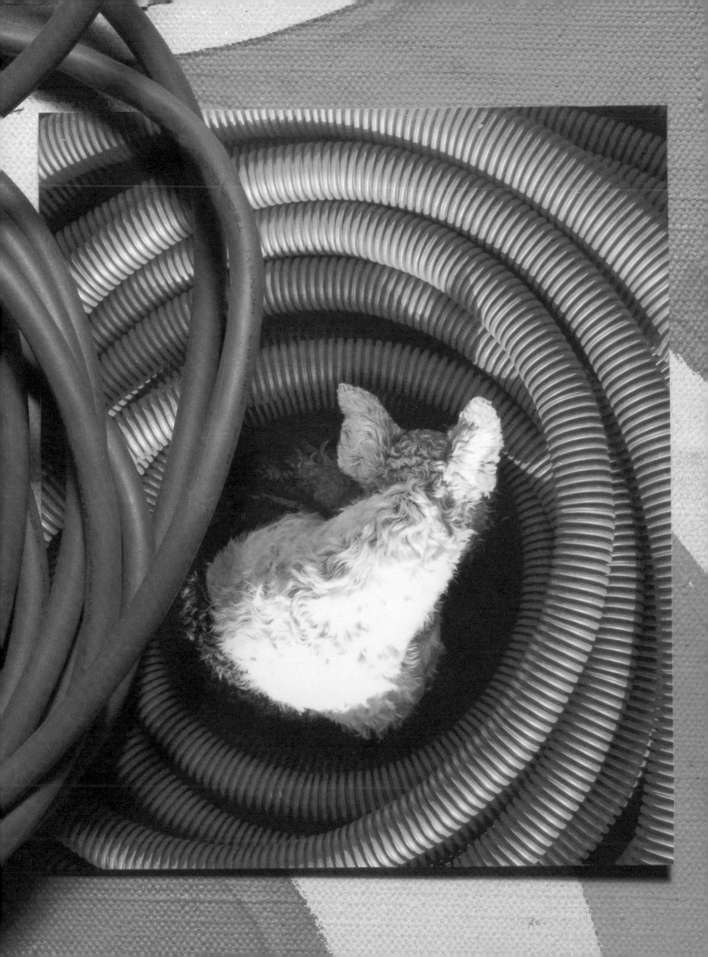

THE HAUL

McDUFF AND I LOVE TO VISIT SECONDHAND
STORES AND MARKETS. WE ROOT AROUND
FOR INTERESTING PIECES, THEN HE STANDS
GUARD NEXT TO OUR FINDS. HIS WILLINGNESS
TO BE PART OF THE HUNT INSPIRES ME. I
GLANCE OVER AT HIM, SITTING AND LOOKING
REGAL, PROTECTIVELY STATIONED BY THE
DISCARDED PAINTINGS I RESCUE AND VARIOUS
TCHOTCHKES I SET ASIDE TO INCORPORATE
INTO AN ASSEMBLAGE. OTHER SHOPPERS COO
AT HIS CUTE FACE AND SCRATCH HIS HEAD.
WE ARE A PERFECT TEAM.

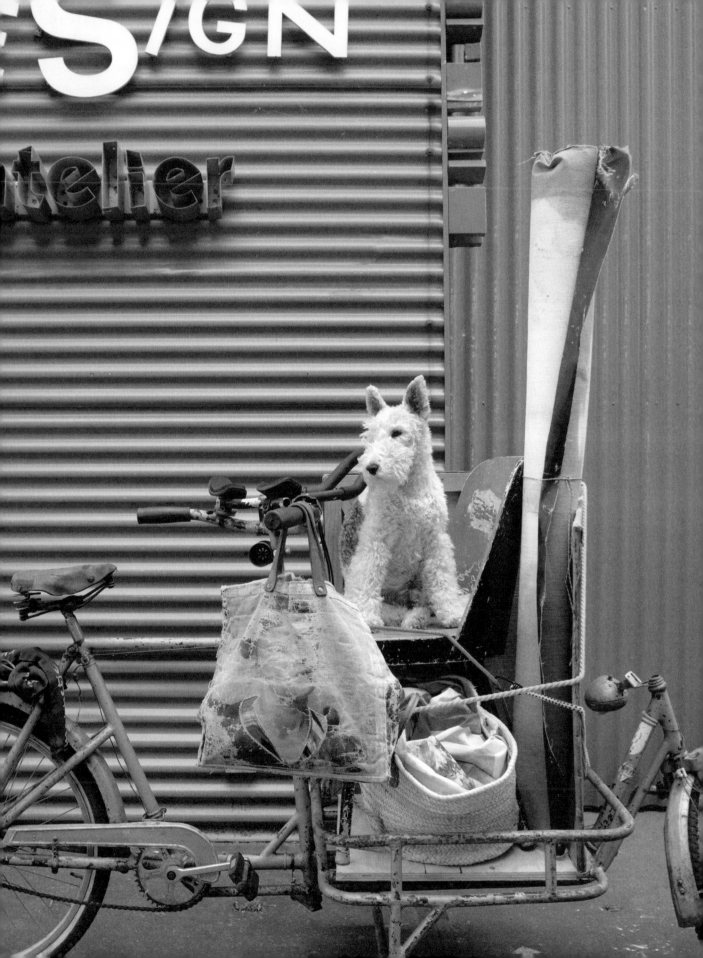

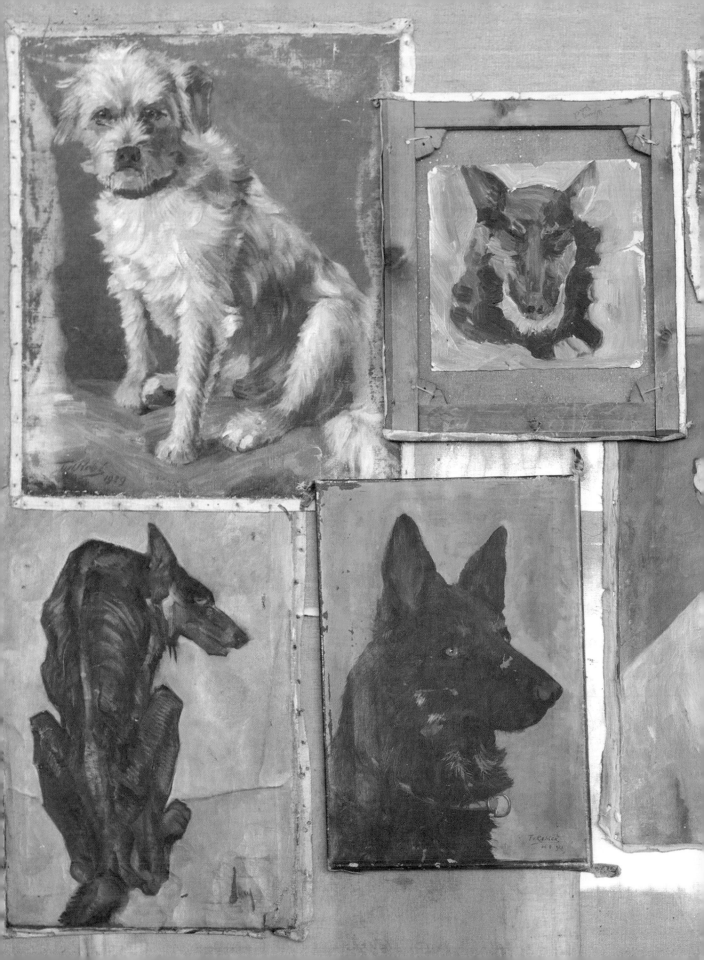

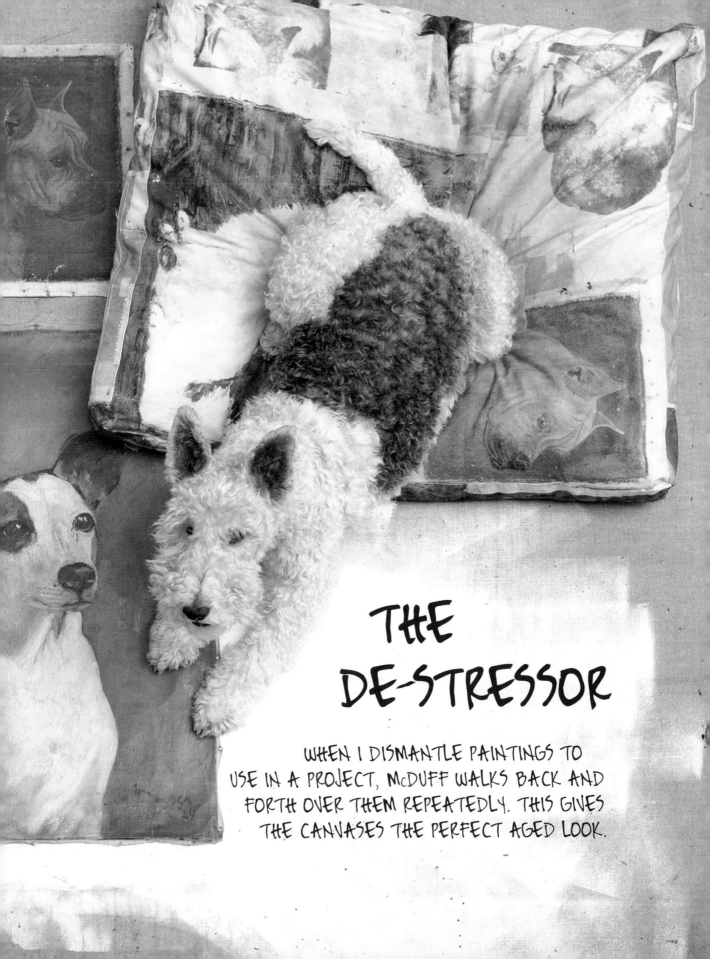

THE DE-STRESSOR

WHEN I DISMANTLE PAINTINGS TO USE IN A PROJECT, McDUFF WALKS BACK AND FORTH OVER THEM REPEATEDLY. THIS GIVES THE CANVASES THE PERFECT AGED LOOK.

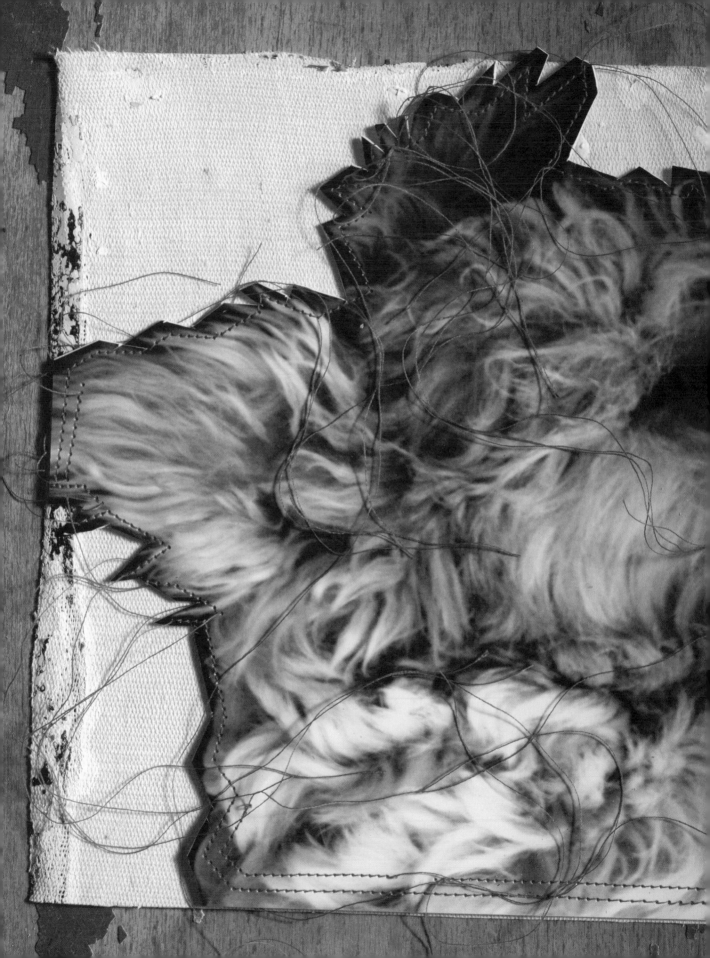

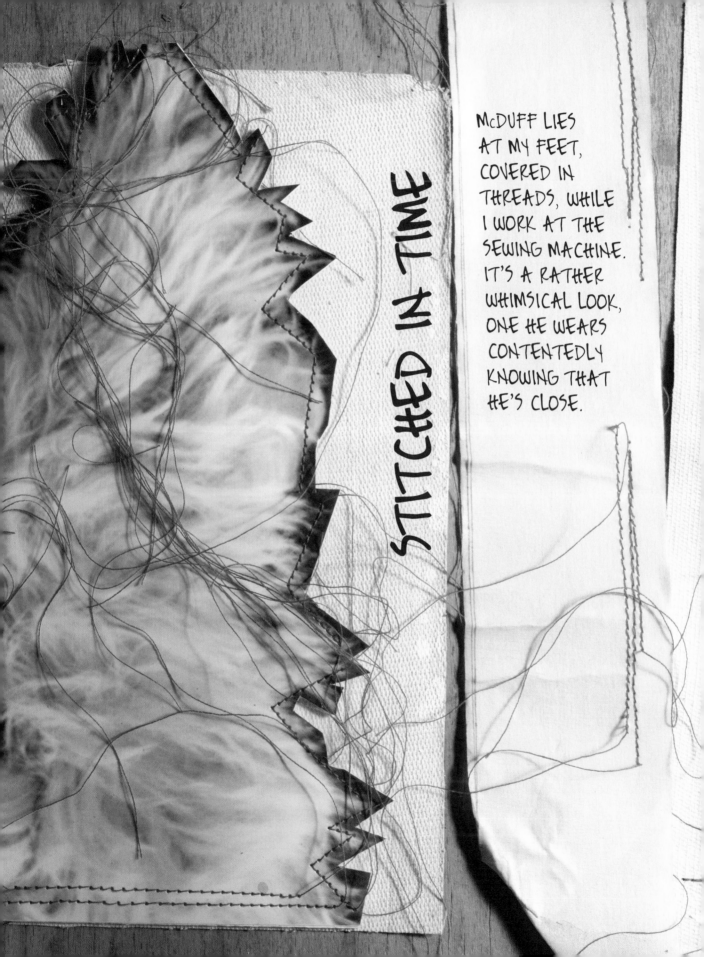

STITCHED IN TIME

McDUFF LIES AT MY FEET, COVERED IN THREADS, WHILE I WORK AT THE SEWING MACHINE. IT'S A RATHER WHIMSICAL LOOK, ONE HE WEARS CONTENTEDLY KNOWING THAT HE'S CLOSE.

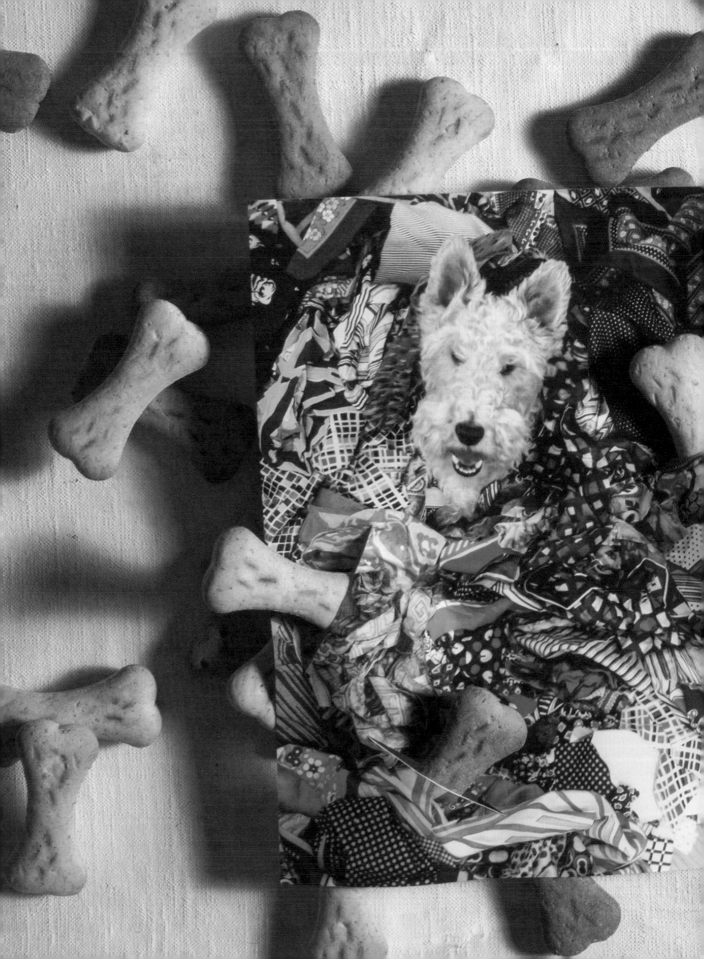

RAG
AND
BONE

MCDUFF LOVES TO BURY
HIS BONES IN PILES
OF FABRIC, WHICH I
INVARIABLY FIND WHILE
RIFLING THROUGH THEM. I
HOLD THE BONE UP, AND
HE STARES BACK AT
ME AS IF TO SAY, "JUST
PUT IT BACK WHERE YOU
FOUND IT, LADY."

IF I GO THRIFTING WITHOUT McDUFF, I BUY HIM A STUFFED ANIMAL. WHEN I GET HOME, HE KNOWS THERE'S A PRESENT FOR HIM AND SNIFFS MY SHOPPING BAGS EAGERLY. I HAND HIM THE TOY, THEN HE METICULOUSLY RIPS A TINY HOLE IN IT AND PULLS OUT ALL THE STUFFING. ONCE HE EMPTIES THE SHELL, HE HAS TO WEAR IT. MY HOUSE, MY RULES.

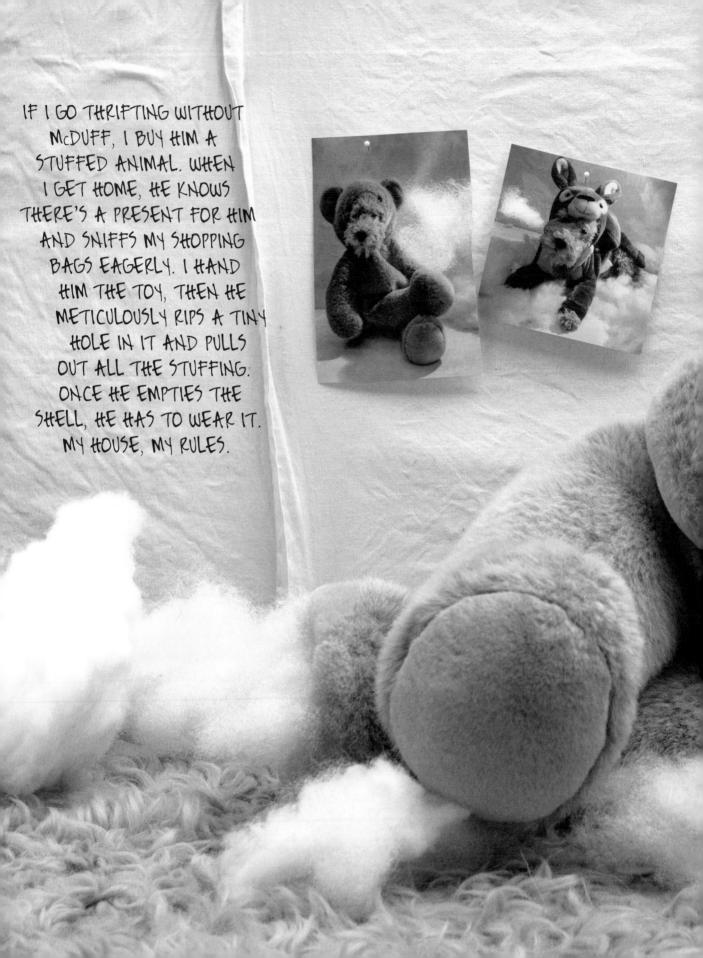

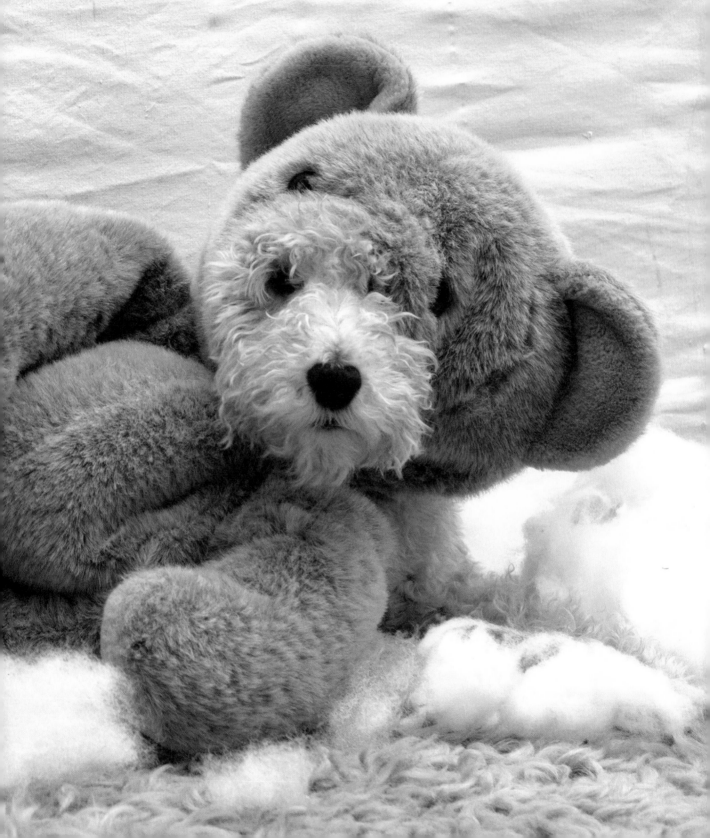

YOU ARE WHAT YOU EAT

I HAD BEEN WORKING ON A FELTING
PROJECT WITH BLACK WOOL AND IT
WAS EVERYWHERE. WHEN I WOKE THE NEXT
MORNING, McDUFF GREETED ME WITH A
STRATEGICALLY PLACED BIT OF FELT FUZZ.
VOILA: CINDY CRAWFORD!

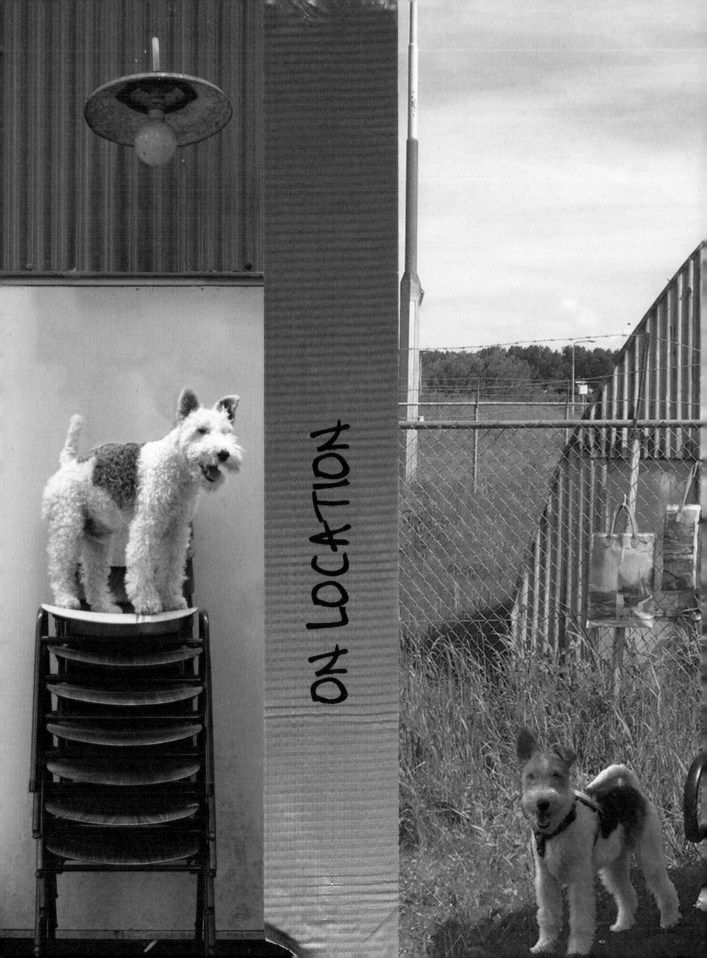

ON LOCATION

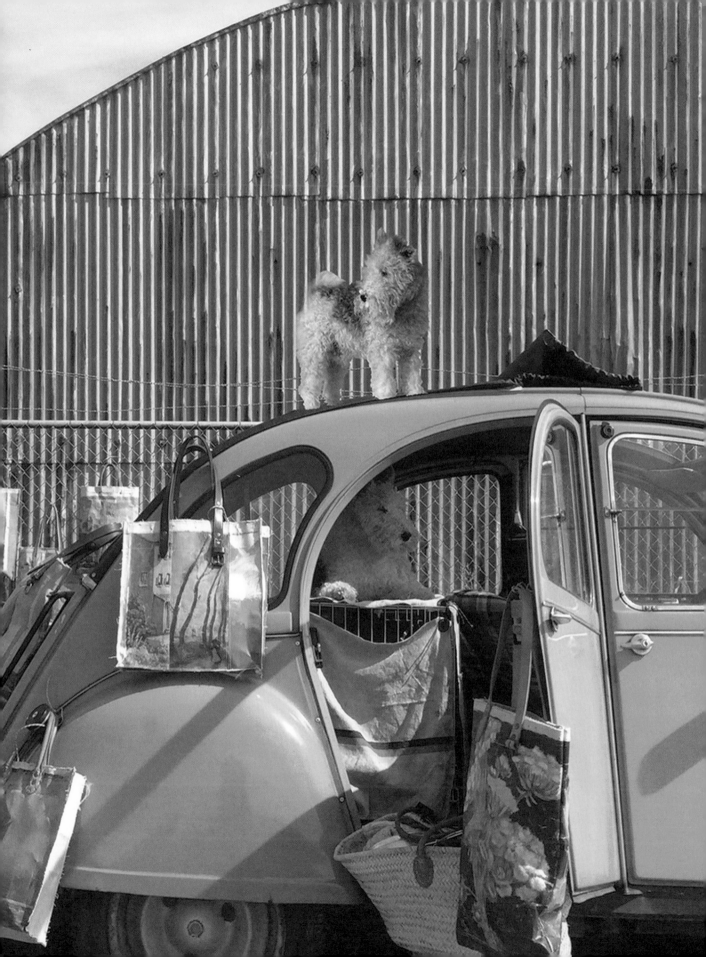

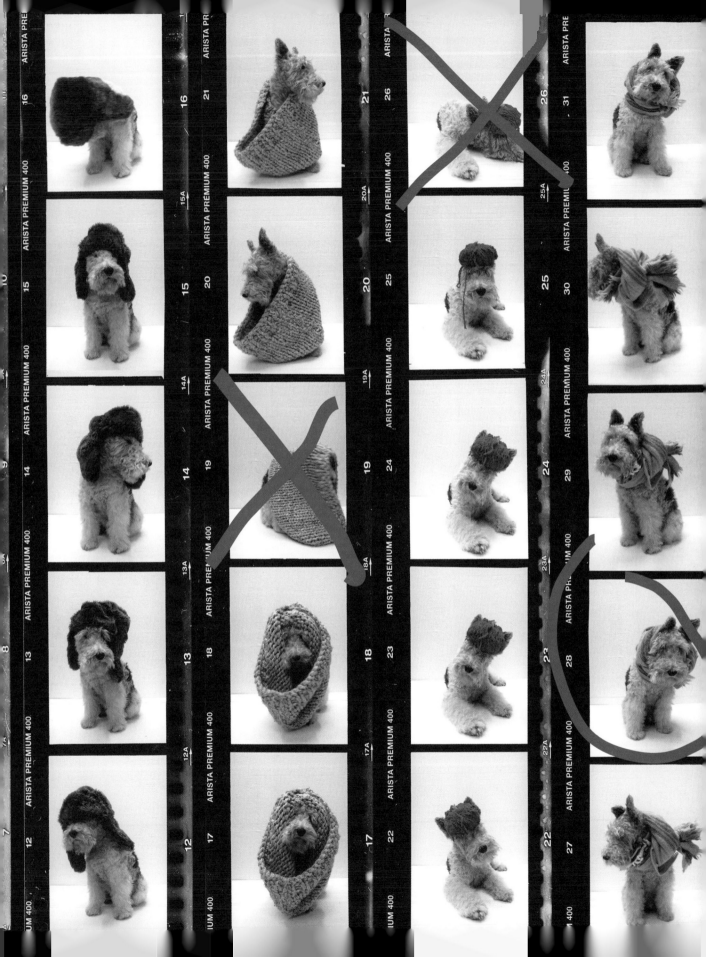

McDUFF
OUTTAKES

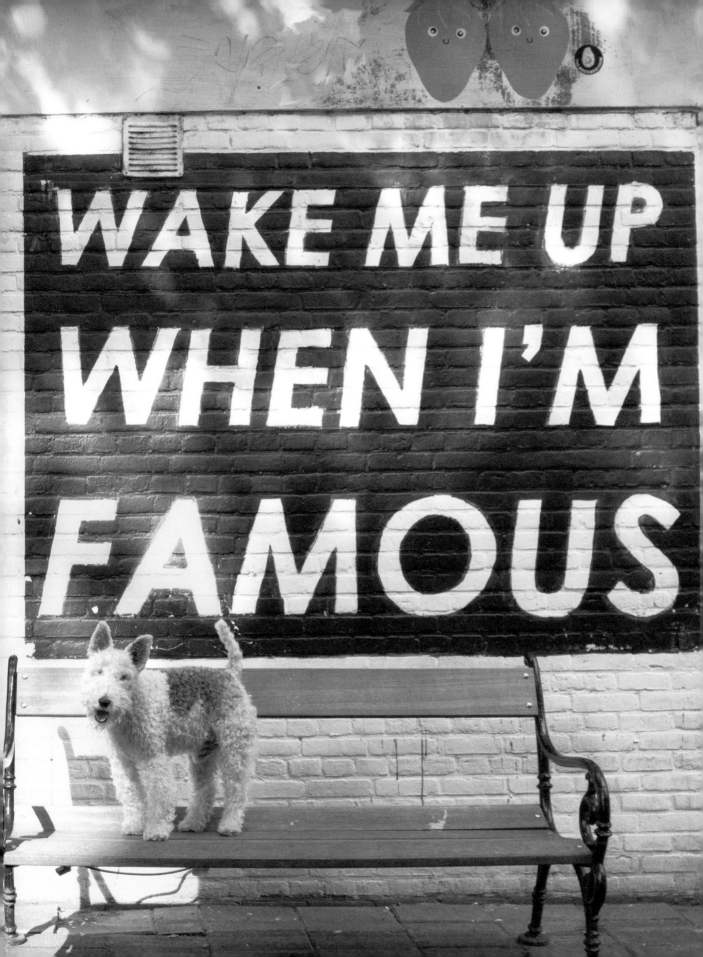

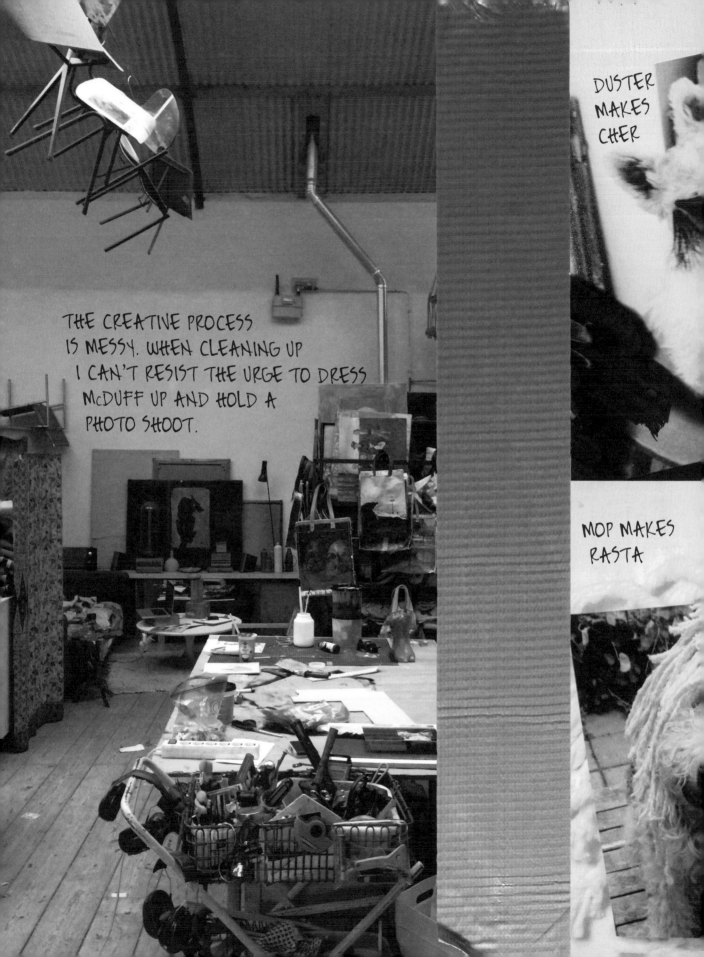

THE CREATIVE PROCESS
IS MESSY. WHEN CLEANING UP
I CAN'T RESIST THE URGE TO DRESS
McDUFF UP AND HOLD A
PHOTO SHOOT.

DUSTER
MAKES
CHER

MOP MAKES
RASTA

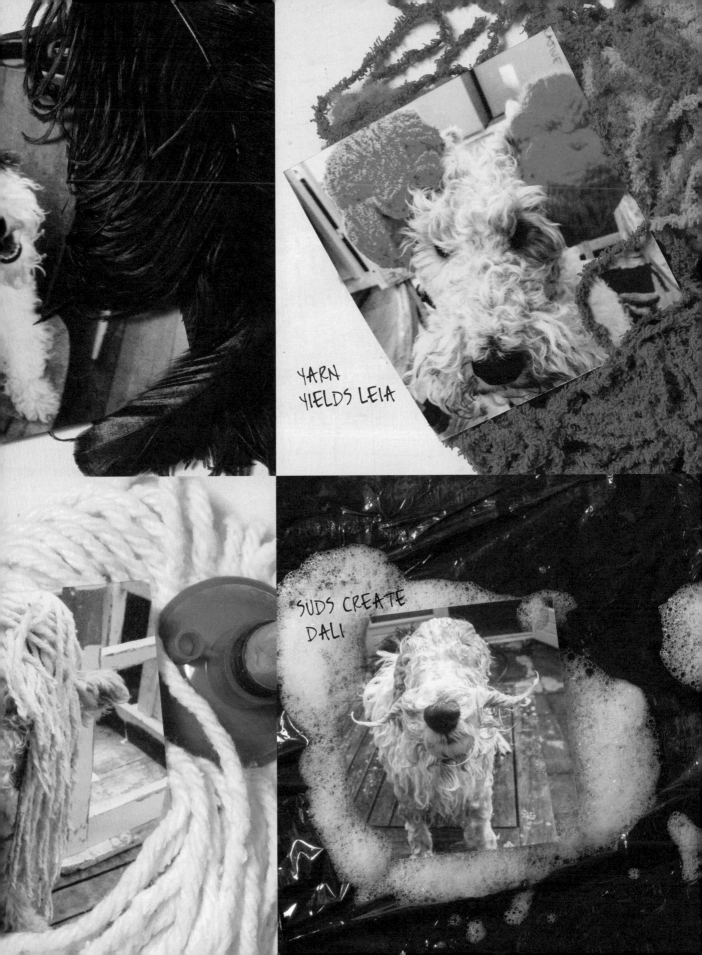

YARN
YIELDS LEIA

SUDS CREATE
DALI

LEGEND:
1 - HOME = BELL
2 - CAR PARK
3 - TRAM STOP
4 - CENTRAL STATION
5 - DOG POUND

FOR WHOM THE BELL TOLLS

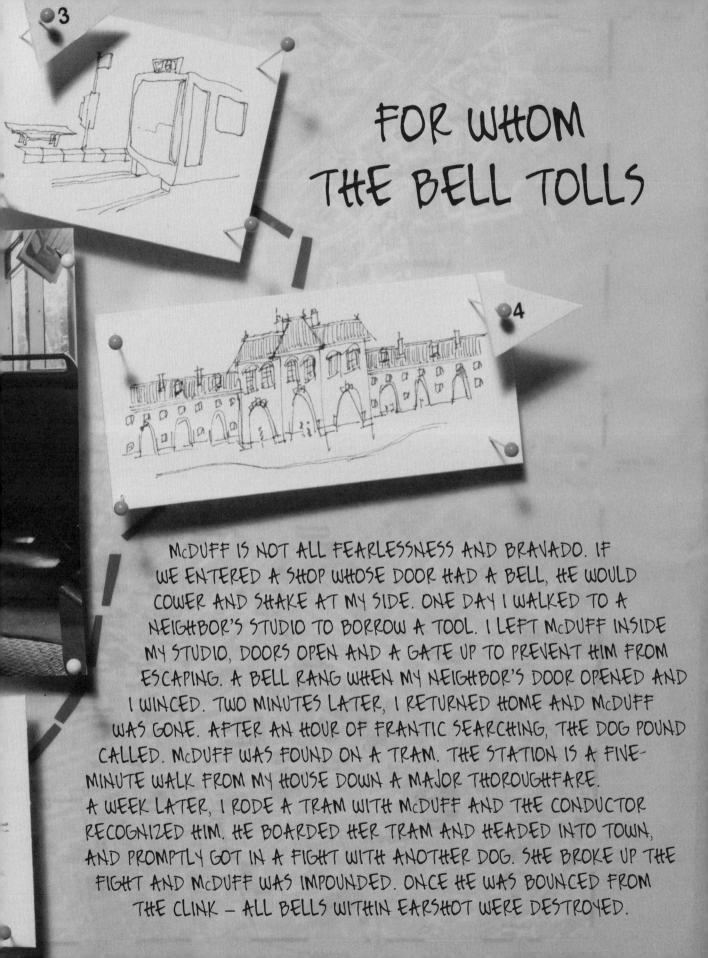

McDUFF IS NOT ALL FEARLESSNESS AND BRAVADO. IF WE ENTERED A SHOP WHOSE DOOR HAD A BELL, HE WOULD COWER AND SHAKE AT MY SIDE. ONE DAY I WALKED TO A NEIGHBOR'S STUDIO TO BORROW A TOOL. I LEFT McDUFF INSIDE MY STUDIO, DOORS OPEN AND A GATE UP TO PREVENT HIM FROM ESCAPING. A BELL RANG WHEN MY NEIGHBOR'S DOOR OPENED AND I WINCED. TWO MINUTES LATER, I RETURNED HOME AND McDUFF WAS GONE. AFTER AN HOUR OF FRANTIC SEARCHING, THE DOG POUND CALLED. McDUFF WAS FOUND ON A TRAM. THE STATION IS A FIVE-MINUTE WALK FROM MY HOUSE DOWN A MAJOR THOROUGHFARE. A WEEK LATER, I RODE A TRAM WITH McDUFF AND THE CONDUCTOR RECOGNIZED HIM. HE BOARDED HER TRAM AND HEADED INTO TOWN, AND PROMPTLY GOT IN A FIGHT WITH ANOTHER DOG. SHE BROKE UP THE FIGHT AND McDUFF WAS IMPOUNDED. ONCE HE WAS BOUNCED FROM THE CLINK — ALL BELLS WITHIN EARSHOT WERE DESTROYED.

THE CLINK

AT ONE POINT, I WAS
HEADHUNTED FOR A
PRESTIGIOUS JOB IN LONDON.
LEAVING McDUFF BEHIND FOR
THE FIRST TIME, I WENT TO
CHECK IT OUT. FROM THE TRAIN,
I SAW A WOMAN WALKING HER
DOG IN THE PARK. McDUFF SPRANG
TO MIND, OF COURSE. HOW COULD I
GO BACK TO WORKING IN AN OFFICE?
WHAT DOG WOULD GET PAW PRINTS
ON MY PROJECTS THERE? RETURNING
TO A CORPORATE JOB WOULD BE MY
PERSONAL DOG JAIL. McDUFF
HELPED ME UNDERSTAND MYSELF
BETTER THAN I EVER HAD: TO BE
HAPPY, I NEEDED TO ROAM FREELY,
WITH McDUFF AT MY SIDE;
TO BE ABLE TO DROP EVERYTHING
AND PLAY WITH MY DOG.

I DECLINED THE JOB.

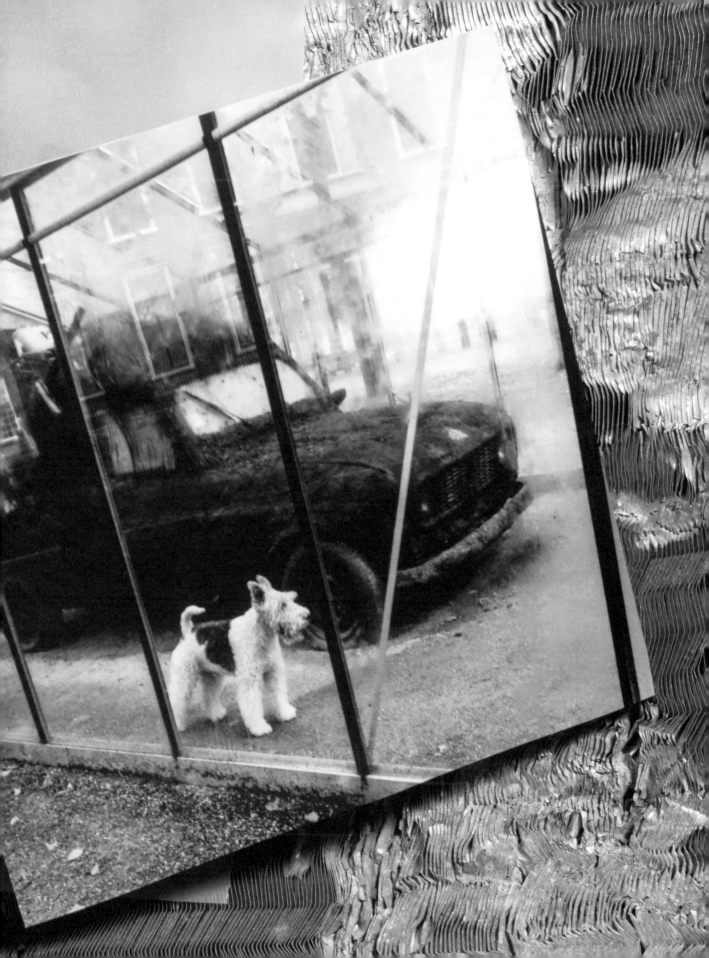

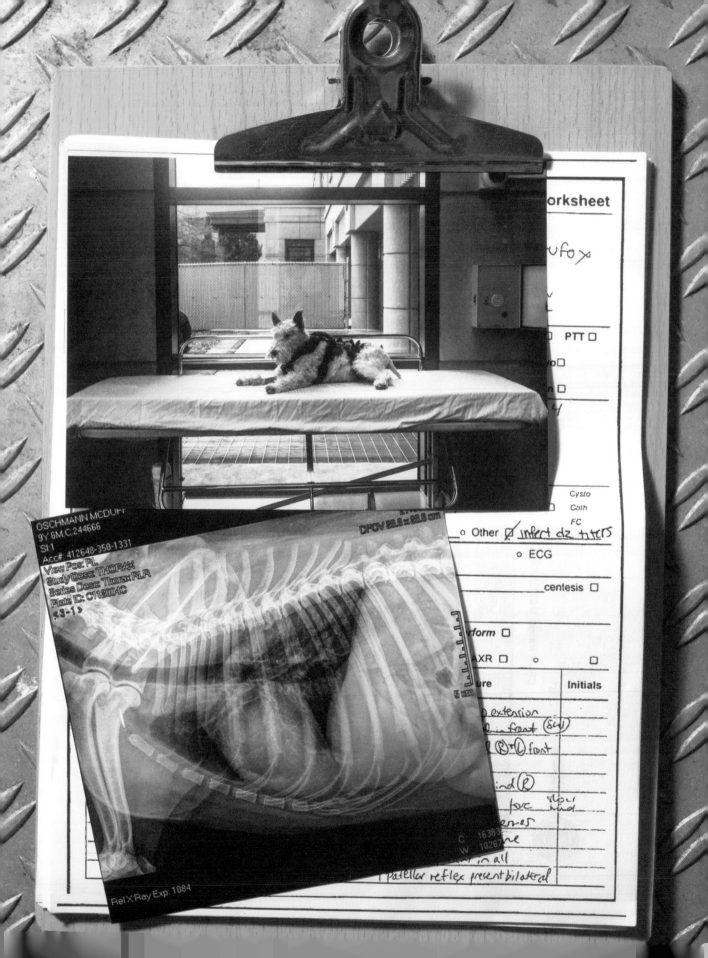

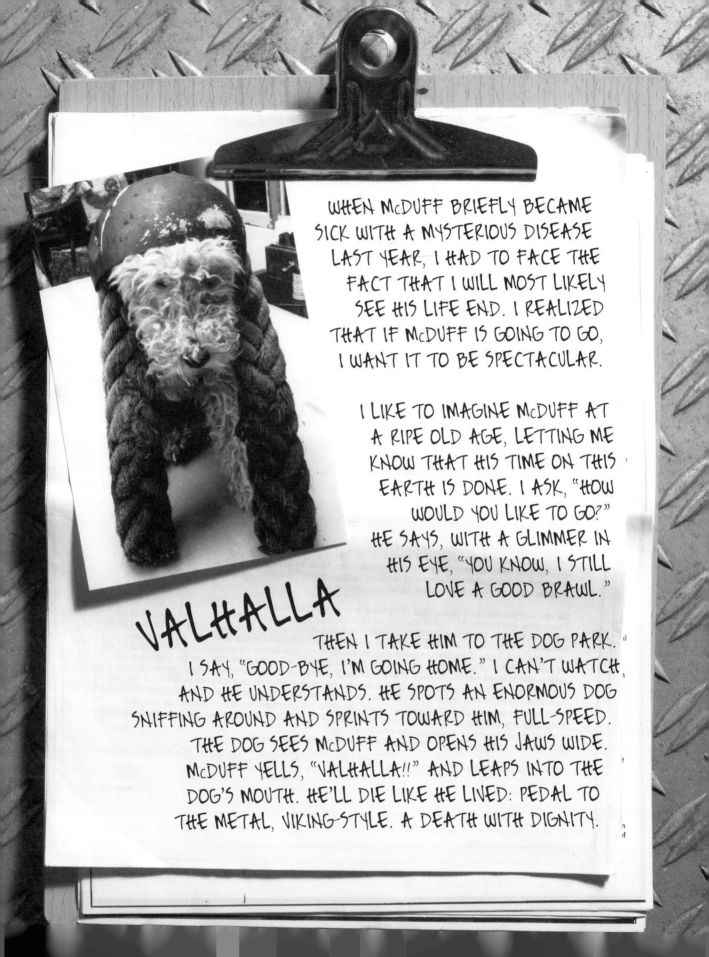

WHEN McDUFF BRIEFLY BECAME SICK WITH A MYSTERIOUS DISEASE LAST YEAR, I HAD TO FACE THE FACT THAT I WILL MOST LIKELY SEE HIS LIFE END. I REALIZED THAT IF McDUFF IS GOING TO GO, I WANT IT TO BE SPECTACULAR.

I LIKE TO IMAGINE McDUFF AT A RIPE OLD AGE, LETTING ME KNOW THAT HIS TIME ON THIS EARTH IS DONE. I ASK, "HOW WOULD YOU LIKE TO GO?" HE SAYS, WITH A GLIMMER IN HIS EYE, "YOU KNOW, I STILL LOVE A GOOD BRAWL."

VALHALLA

THEN I TAKE HIM TO THE DOG PARK. I SAY, "GOOD-BYE, I'M GOING HOME." I CAN'T WATCH, AND HE UNDERSTANDS. HE SPOTS AN ENORMOUS DOG SNIFFING AROUND AND SPRINTS TOWARD HIM, FULL-SPEED. THE DOG SEES McDUFF AND OPENS HIS JAWS WIDE. McDUFF YELLS, "VALHALLA!!" AND LEAPS INTO THE DOG'S MOUTH. HE'LL DIE LIKE HE LIVED: PEDAL TO THE METAL, VIKING-STYLE. A DEATH WITH DIGNITY.

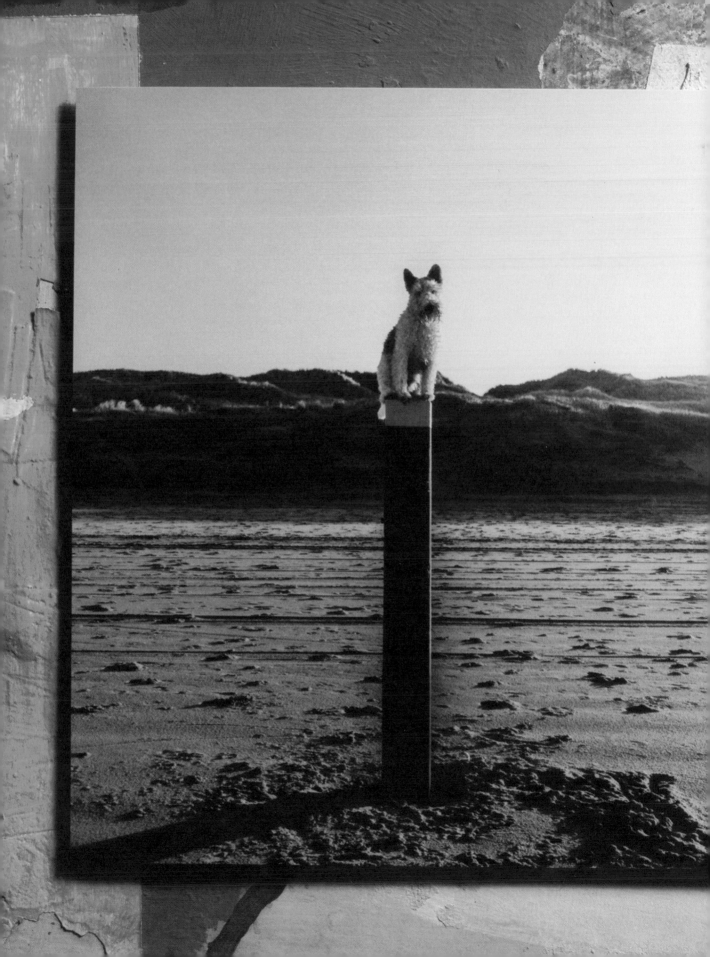